The Watson-Guptill Handbook
of LANDSCAPE
PAINTING

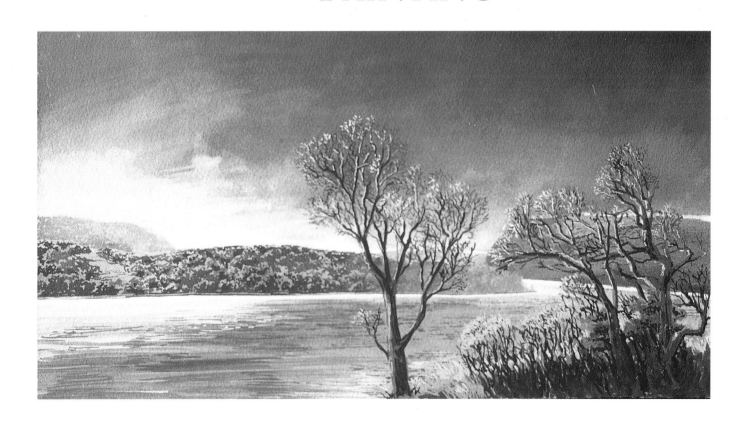

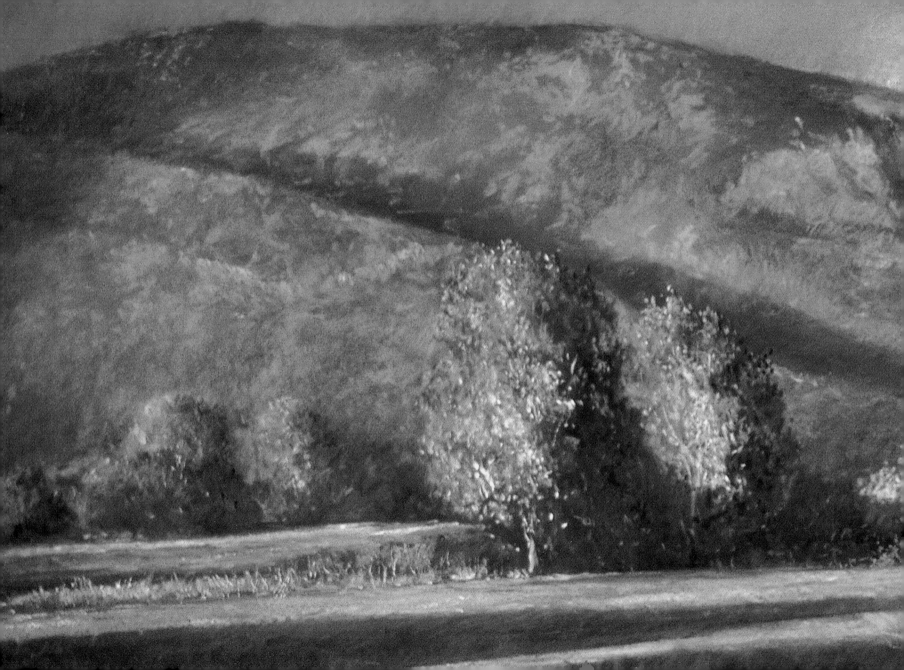

The Watson-Guptill Handbook
of LANDSCAPE
PAINTING

M. Stephen Doherty

WATSON-GUPTILL PUBLICATIONS/NEW YORK

Half-title page:
DARK SKY OVER THE HUDSON, 1995
Acrylic, 11 × 18" (27.9 × 45.7 cm).

Title page:
CAT MOUNTAIN: FORBES TRINCHERA RANCH,
by Gil Dellinger, 1996
Pastel, 20 × 60" (50.8 × 152.4 cm).
FORBES Magazine Collection.

First published in 1997 in the United States
by Watson-Guptill Publications,
a division of BPI Communications, Inc.,
1515 Broadway, New York, N.Y. 10036.

Library of Congress Catalog Card Number: 97-061138

Printed in Singapore

First printing, 1997

1 2 3 4 5 6 7 8 / 04 03 02 01 00 99 98 97

M. Stephen Doherty is Editor-in-Chief of both
American Artist and *Watercolor* magazines. He graduated
summa cum laude from Knox College in Galesburg,
Illinois, and earned a Master of Fine Arts degree from
Cornell University in Ithaca, New York. He has written
dozens of magazine articles and several art books,
including *Dynamic Still Lifes in Watercolor* and *Business Letters
for Artists* (both for Watson-Guptill Publications, Inc.),
and *Creative Oil Painting* (Rockport Publishers). He
frequently conducts workshops, offers critiques, and
judges art exhibitions. He recently presented solo
exhibitions of his own paintings and prints at Ferris
State University and the Bryant Galleries in Jackson,
Mississippi, and New Orleans, Louisiana. Doherty lives
in Croton-on-Hudson, New York, with his wife Sara,
and their children, Clare and Michael.

Senior Editor: Candace Raney
Edited by Sylvia Warren
Designed by Areta Buk
Graphic production by Hector Campbell

Contents

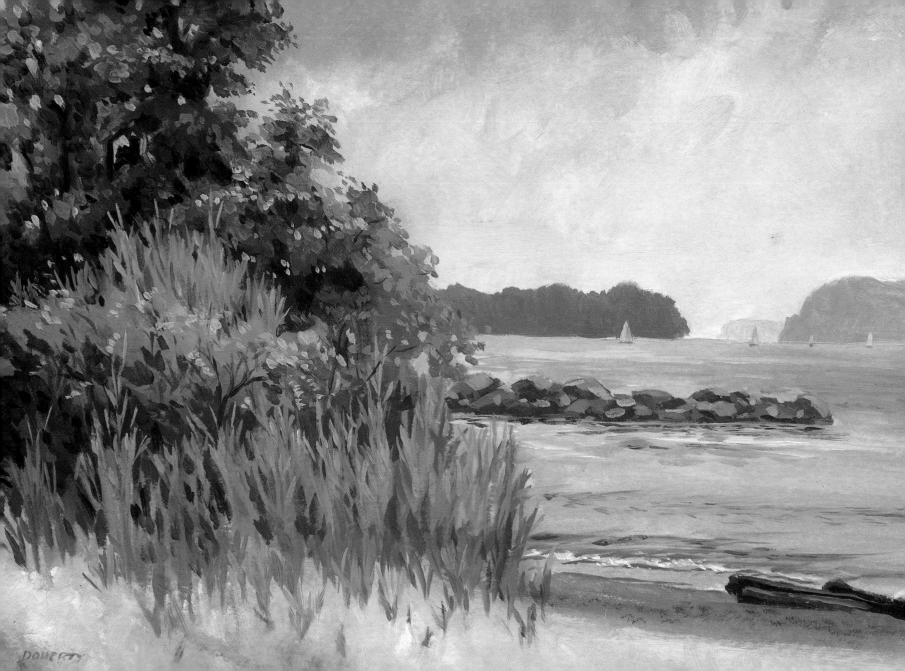

INTRODUCTION

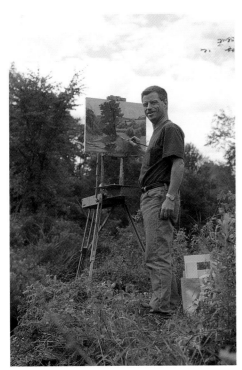

(Above) *The author, set up along a stream in upstate New York.*

(Opposite) FATHER'S DAY ON THE
HUDSON, 1994
Alkyd, 11 × 14" (27.9 × 35.6 cm).
Collection of the artist.

Each of us has an idea of what is and what is not a landscape painting, and our ideas are based on our personal standards and experiences. Since this is my book, I have used my ideas and my definition: A landscape painting is a painting of objects in an outdoor space. That's a fairly broad definition, but I think it brings focus to the topic while allowing artists to be creative. I include, for example, urban scenes, historic homes, gardens, and cloud formations but exclude abstract compositions.

One of the most exciting aspects of painting any type of landscape is making decisions about the elements to be viewed within the segment of the world confined by the edges of the paper, canvas, or board. Each tree, waterfall, and cloud is brought to life by the artist with his or her paintbrush in a unique way. Throughout this book you will see examples of ways you might handle the techniques available to you for creating your own landscape reality. The text is based on my own extensive experience and on information I've absorbed through interviewing artists over the last eighteen years as editor-in-chief of both *American Artist* and *Watercolor* magazines, and reading about the great landscape painters of the past in exhibition catalogs and books. The demonstrations, which are based on my own paintings, present a few of the available options—ideas about equipment, approach, media, and techniques—and as you experiment with art materials and look at landscapes painted by other historic and contemporary artists, you will discover many other options on your own.

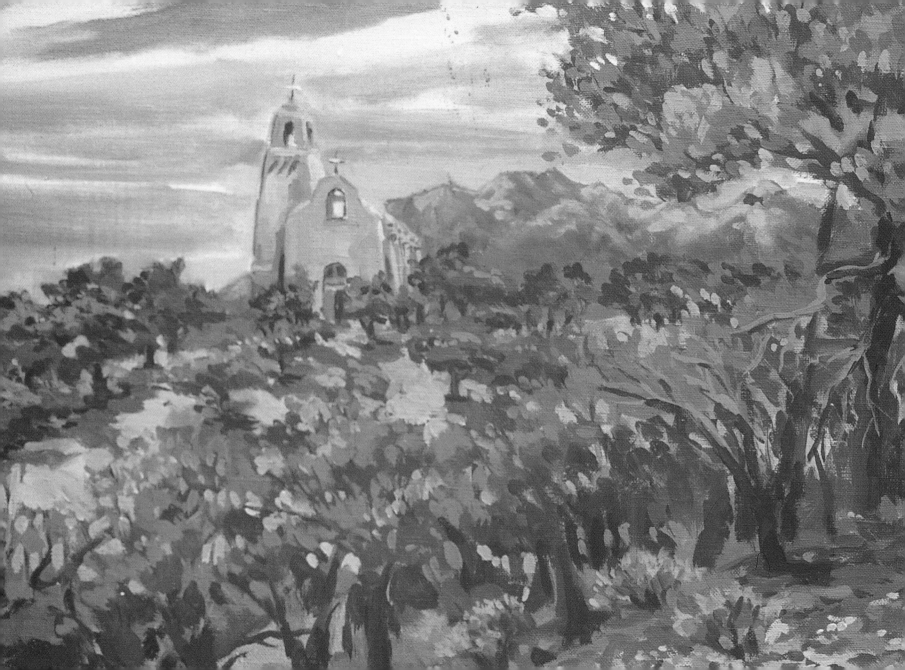

CHAPTER 1

ORGANIZING YOUR EQUIPMENT

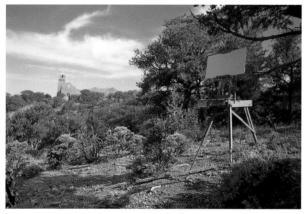

(Above) The range of supplies I'm able to take into a landscape depends on the convenience of the location. The Hudson River painting shown on the opening page of the Introduction was done along a road where I could park my van full of supplies, so I carried a wide assortment of paints and brushes with my easel. This Colorado landscape, on the other hand, was painted from the top of a steep hill I could reach only by climbing, carrying one bag full of supplies and my French easel.

(Opposite) CHAPEL AT THE
FORBES TRINCHERA RANCH (detail), 1996
Alkyd, 12 × 24" (30.5 × 61 cm). Collection of the artist.

An experienced artist should be able to create a respectable painting out of whatever supplies happen to be available, whether or not the palette of colors is complete, the surface is well prepared, the brushes have plenty of spring, or the easel is just the right size. But the truth is that like a cook who has a favorite pan or a golfer who depends on a certain set of clubs, artists develop a dependency on their equipment. They want a finely woven Belgian linen canvas, a tube of rose madder genuine, a Kolinski sable brush, or a bottle of copal painting medium.

Part of the fun of being a landscape painter is selecting just the right set of equipment and keeping it organized in your studio or vehicle. If you know everything is in its designated place waiting to do its job at a moment's notice, you can move from idea to action without wasting time.

This chapter includes brief descriptions of some of the most commonly used pieces of equipment so you can make the selections most appropriate to your manner of working. To explore the subject further, visit your local art materials retailer or flip through the pages of a direct-mail catalogue.

Viewers

From top left, counterclockwise: The simplest viewer—your own hands; the John Pike Wonderful Perspective Machine; a Zoomfinder; homemade window viewer with grid lines drawn on Mylar plastic; mat board cut to make a simple viewer.

Because your eyes can take in much more of the landscape than will ever fit within the space of a canvas or panel, you need to isolate a portion of the view and determine how it will fit within that rectangular, circular, or square space. You need to ask yourself the questions: What parts will be included? Where will the center of interest be? How large or small should objects be to fit within the picture? The answers to those questions can be determined with the aid of a viewer, one that is as simple as your hands held up in front of your eyes to frame the portion of the landscape you want to paint, or as complicated as an adjustable viewer marked off with horizontal and vertical lines to help you judge distances and proportional relationships.

There are a number of commercially made viewers on the market that are valuable aids. The John Pike Wonderful Perspective Machine is made of blue plastic that filters the colors in the landscapes so you can

more accurately judge value relationships. Two pieces of metal come with the Pike viewer that can be laid across the magnetic border so you can line up the edges of buildings, street lamps, etc. The plastic Zoomfinder is another calibrated viewer that allows you to look through variously proportioned rectangles and squares to determine the best composition of your picture.

You could easily make your own viewer with a window cut into a piece of mat board and calibrated along its edges, or with a couple of L-shaped pieces of mat board that can be moved back and forth until you find the right shape for your composition. If you decide to use the window viewer, you might want to consider gluing pieces of red string across the opening at spaced intervals or taping a piece of clear Mylar over the opening and drawing lines across it to help you place the elements of the landscape on a similarly gridded canvas, paper, or panel.

If you work from photographs or small sketches, you might consider buying a projector that will simplify the process of enlarging and transferring the image onto the painting surface. Slides can be projected through a standard Kodak Carousel projector, and opaque artwork (photographic prints, drawings, color sketches, etc.) can be enlarged onto the painting surface with an Artograph opaque projector. Whichever piece of equipment you use, the process involves tracing the lines of your drawing or the outlines of the various shapes in your photograph. You can adjust the scale of each element you include in the traced drawing, pull pieces out of several photographs or sketches to make one composite image, and clean up rough lines and brush strokes before you begin painting you picture.

A projector is particularly useful if you are considering adding a figure or building to a landscape and you aren't sure about the appropriate scale or placement. Projecting the image allows you to judge its impact on the total composition before you actually paint it in. You could even project the figure or building onto a sheet of translucent paper, trace the image, and then move the sketched figure or building around over the existing painting. David Ligare, whose painting *Landscape with Man Drinking from a Spring* is shown at the end of this chapter, often begins a painting by projecting a photographic image of his subject onto canvas.

OTHER TRANSFER SYSTEMS

If you don't want to bother with a projector, you can use a photocopier to enlarge a photograph or sketch to the size of your painting surface. It may be difficult to determine the exact percentage of increase you will need, but through a process of trial and error you'll come up with an enlargement that will fit your painting surface.

A grid system can also be used to enlarge a photograph or sketch. You simply draw lines over the sketch at measured intervals and plot out the same division on the larger piece of canvas, paper, or board. The grid helps you judge where to place each line of the sketch or photograph on the painting surface.

The old masters made cartoons of their preliminary sketches by punching pinholes along the lines of their full-scale drawings, holding the perforated drawings up against the plastered walls or prepared canvases, and pouncing powdered charcoal or chalk through the holes. Some of the pouncing wheels available today still punch holes; others burn tiny holes through the drawing paper.

You can also apply graphite to the backside of a full-scale drawing and transfer the image by redrawing the lines while the paper is held up against the painting surface. If you prefer to avoid this somewhat messy technique, another option is to use Saral graphite paper.

An Artograph opaque projector.

A slide projector.

Easels

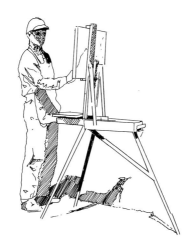

An artist standing at a half French easel.

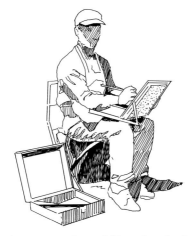

An artist seated on a folding chair (with storage bag below) using a pochade box.

PORTABLE EASELS

Artists who paint while they travel are always in search of the perfect easel, one that is light enough to be hauled deep into the forest, durable enough to survive the abuse of airport baggage handlers, compact enough to travel as carry-on luggage, spacious enough to hold all the paints and brushes they need, and inexpensive enough for an artist to be able to afford. Needless to say, that easel doesn't exist. The next best thing is one of the portable easels made specifically for artists who travel to their painting sites.

The French easel and half French easel are two of the most popular pieces of portable equipment. The telescopic legs and retractable canvas holder allow the easel to be folded into a compact unit that most flight attendants think is a piece of surveying equipment. As the names indicate, the French easel is about twice as large as the half French easel. Both usually come with straps for carrying the easels on your back or in your hands.

There are a number of other portable easels on the market for oil painting and watercolor painting. Some come with seats, others with swing-out palette holders, and a few with extensions for larger canvases or sheets of paper. It's a good idea to look one over before buying it. Make sure the hinges are secure, that you can manage the weight, that you can unfold and fold it without trouble, and that you will be comfortable working at it. Some portable easels put the palette in a location that makes it hard to lean into a picture, and others are difficult to unfold without a vise grip.

POCHADE BOXES

Pochade boxes are portable paint boxes designed to hold paints, brushes, and panels and at the same time provide a rigid back against which the panel can be supported while you are painting. Most include the rigid support in a lid that also serves as a slotted storage space for wet pictures. Many have palettes that slide along grooves so they can cover the stored paints and brushes. A few pochade boxes have tripod mounts on the bottom into which you can screw a camera tripod so the box will support itself if you want to paint standing up.

Pochade boxes, which are usually the size of cosmetic cases or briefcases, can be carried most anywhere. If you can find a spot inside the box for solvent, water, and painting medium, you'll have everything you need to paint at a moment's notice.

STUDIO EASELS

A studio easel is like a heavy piece of furniture. It must perform its function in the room in which it has been placed. Thus the weight and size of the easel are less important than its ability to hold variously sized canvases or papers and to be adjusted without a great deal of effort. Here again you should try one out in a store or in a friend's studio before investing a lot of money. An easel can be just as expensive as a good quality sofa. Some make it easy to raise and lower the canvas ledge, others store flat against the studio wall, and some tilt easily when used for watercolor painting.

The diagrams here show you the most common shapes for paintbrushes. Each is designed to make a specific kind of mark on the painting surface. As you might imagine, a flat brush delivers a broad stroke of paint while a liner makes a long, thin line. A fan brush works well for stippling the paint or gently blending colors. Round brushes are versatile: they can be used to paint lines of various widths or dots.

The type of hair used to make the brush will predispose it to be used for a specific kind of paint and to make a certain kind of mark. Soft sable hairs are ideal for holding and then releasing watercolor, while stiff bristles are well suited for stroking oil paint onto a textured canvas.

Most manufactures label their brushes for use with a particular medium, so you can use that guidance in selecting the brushes you need. If you're unsure what shape to buy, I would recommend starting with round, natural-hair brushes if you're using watercolor; flat and round synthetic-hair brushes for acrylics; and flat or round bristle brushes for oils.

AIRBRUSHES

Many artists avoid using an airbrush because they are afraid it is a difficult piece of machinery to work with, or because they associate it with painted T-shirts or pick-up trucks. The truth is that airbrushes are quite easy to use after a little practice, and they can be very helpful in laying in uniform background, adding sparkling highlights, or painting graduated shadows. And while the equipment may seem expensive at first, for most artists it is probably no more expensive than a six-month supply of sable brushes.

The Medea airbrush company loaned me a compressor and an airbrush when I taught a workshop recently, and the students and I had an enjoyable time discovering how the tools could be used to create the appearance of sharp edges, rounded forms, repeated patterns, etc. In the painting shown here, I taped the edges of the rectangular space, laid stiff paper over the open area of the illustration board, and airbrushed bands of blue, yellow, red, pink, and orange to create the appearance of dusk. Once those layers of paint dried, I used a paintbrush to put in the spots of light.

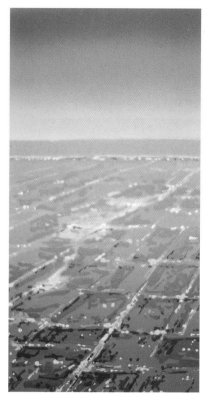

The fine, controllable spray of gouache from an airbrush was used to create the lights of a city one might see through the window of an airplane.

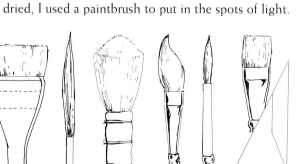

Brushes, from left to right: bright, dagger stripper, fan blender, filbert, fitch, flat, bake, liner, mop, dagger, round, aquarelle.

Palettes

Artists working with water-based paints have special requirements of their palettes. Watercolorists need a tray or segmented dish that separates the colors so they won't mix with each other, and an acrylic painter needs a palette that can be sealed so the fast-drying paints won't harden permanently in the compartments. There are a number of hard plastic palettes manufactured for both types of paint, and one can improvise by using styrofoam egg cartons, enameled butcher trays, or glass plates for watercolor; and acrylic painters can use styrofoam meat trays, airtight fishing tackle boxes, or storage boxes with lids just as easily.

Artists working with oils or alkyds can use an equally varied group of commercially made palettes, including ones made from plywood, plastic, glass, Mylar, and waxed paper (so they can be disposed of after use). Some artists like to lay their paints out on a gray-colored palette, so they can judge the mixtures of colors against a mid-tone value. Others prefer a white palette, which makes it easy to gauge the degree of transparency in a color before applying it to a canvas. For many of the demonstrations shown in this book I used a Paragona glass palette with beveled edges and an opaque white backing. (I like the fact that the smooth surface can be cleaned quite easily, even when paint has dried on it.) I did not use the Paragona palette when painting outdoors, however, because I was concerned that the glass would crack as I hauled the palette up and down mountains or in and out of overhead compartments in airplanes.

Palettes, from left to right: a watercolor palette with separate compartments for each color, an oval palette with a thumbhole used for oil or alkyd, a square palette with a thumbhole used for oil or alkyd.

The most traditional surface for watercolor or acrylic painting is paper, but acrylics will adhere to the widest range of surfaces of any paint. Acrylics can be applied to canvas, wood, fabric, and some plastics. Oil paints are most often applied to either linen or cotton canvas. Wooden panels can also be used for oils, but the weight and potential for warping make them less desirable for large paintings.

The important thing to keep in mind is how the paint actually adheres to the surface on which you apply it, and what potential damage might occur as the paint dries on the surface. Watercolor has a very weak binder, for example, so it must be applied to an absorbent paper that will lock the dried paint into its fibers. The linseed oil in oil paints can cause the fiber of paper or canvas to rot, so the two must be isolated from each other by layers of gesso, glue, or other materials to which the oils can adhere without penetrating down to the paper or cotton.

Oil painters often spend a great deal of time and money preparing the surfaces on which they will paint. Some attach canvas to honeycombed metal plates or braced sheets of plywood, while others tack it to wooden stretcher bars that automatically expand and contract with changes in humidity so the canvas won't become either too loose or too tight. You'll also discover elaborate formulas for sealing canvases or boards with layers of gesso, rabbit skin glue, and/or white lead paint. Those recipes allow the artists to adjust the texture and absorbency of the painting surface and to ensure that the oil paint never comes in contact with the raw canvas.

For those (like me) who prefer to buy ready-made painting surfaces, there are a number of companies that sell preprimed, prestretched canvases as well as prepared panels. For many of the oil painting demonstrations in this book I used a commercially made panel called Gessobord which has a uniform coating of acrylic gesso on a backing sheet of Masonite.

I frequently receive letters from conservators who recommend that oil painters use ABS plastic panels, aluminum-faced panels, or plastic awning cloth for their painting surfaces rather than cotton canvas or wooden boards. Their reasoning is that the metal and plastic will not expand, contract, or decay—changes which cause problems for oil paintings on linen or canvas. The panels and cloth most often recommended by these conservators have to be purchased from industrial suppliers, although there is a company called Hudson Highland which sells a plastic panel for artists called Solid Ground.

Canvases, from top, counterclockwise: the back view of canvas stretched around and stapled to wooden stretcher bars, the back view of a wooden panel, a side view of canvas tacked to a canvas stretcher with recessed adjustments, a back view of a panel cradled with a grid of braces.

PALO ALTO (PINK SKY),
by Mitchell Johnson, 1996
Oil, 22 × 26" (56 × 66 cm).
Courtesy Hackett-Freedman Gallery,
San Francisco.

These two paintings serve as a perfect transition to the next two chapters, Selecting Your Medium and Planning Your Approach. They were done by two California artists who have completely different approaches to landscape painting and who therefore employ different sets of equipment. Mitchell Johnson hauls his large canvases outdoors and uses a viewer to frame the portion of the landscape he wants to paint with active strokes of bright color. David Ligare, on the other hand, works in his studio using photographs projected or scaled onto the canvas to begin the process of painting figures in classical landscapes.

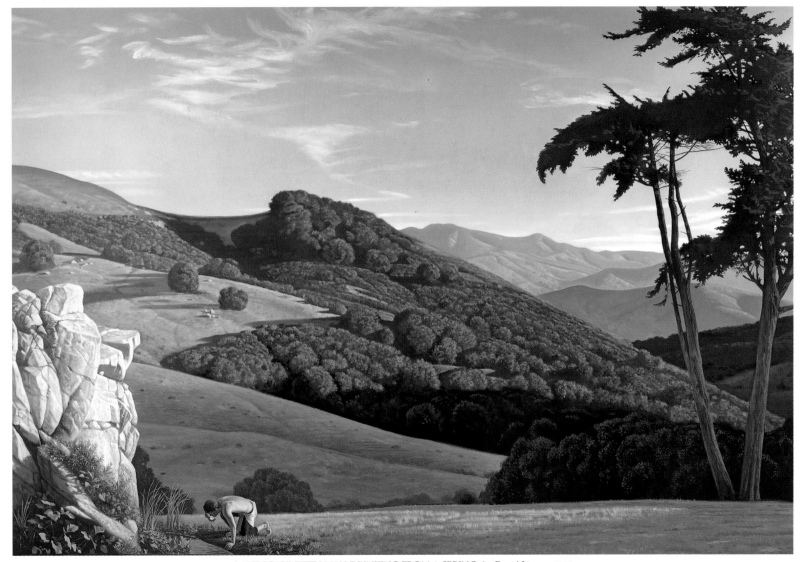

LANDSCAPE WITH MAN DRINKING FROM A SPRING, by David Ligare, 1990
Oil, 80 × 116" (203 × 295 cm). Courtesy Tanimura Antle Corporation, Salinas, California.

Doherty '91

SELECTING A MEDIUM

(Above) ALKYD DEMONSTRATION
10 × 13" (25.4 × 33 cm).

This small alkyd was painted on a gessoed plywood panel with a limited palette of colors and one No. 10 flat bristle brush. There was no time for subtle glazing, careful detailing, or perfect color matching. The point was to record enough information to be able to recreate the scene from memory when I wanted to paint a similar sunset in the studio.

(Opposite) MOHONK NO. 3, 1991
Gouache on tan Arches paper, 12 × 18" (30.5 × 45.7 cm).
Collection of the artist.

It is possible to paint the same subject with two or three different kinds of paint and come up with pictures that are almost exactly alike in surface appearance. Acrylics can be made to have the glossiness and translucence of oils; gouache can appear to have the matte, dense look of acrylics; and acrylics can be applied in thin washes so they appear deceptively like watercolors. But the fact remains that each paint has certain natural characteristics that artists prefer to exploit rather than conceal. The hallmark of a great watercolor is its transparency, a great oil has a glow and brilliance, and a great acrylic painting demonstrates the versatility of the medium.

In this section I'll try to suggest some of the ways of using the natural tendencies of oil, alkyd, watercolor, gouache, pastel, and acrylic paints. In the end, the only way to determine which is the best medium for your landscapes is to try them out. Once you feel the paint flowing from the end of your brush and you see the way the paint looks on your paper, canvas, or board, you'll know if it is the right one for you.

Oils and Alkyds

Oils are not the oldest painting medium, but they have certainly been the most important in the history of western art, and the reputation of most of the old masters was based on the oil paintings he or she exhibited. Yet there is nothing that makes oils inherently superior to other paints. Oil colors do have the highest refractive index of all painting mediums, making them richer and deeper in color, but that's not why dealers, curators, historians, and critics tend to place greater value on oil paintings than on watercolors, pastels, or acrylics. The best explanation is tradition. It's just always been that way.

What makes oils so special? Well, they certainly offer artists an opportunity to use a wide variety of techniques for creating images on either a large or a small scale. They can be applied in thick impressionistic strokes, thin Dutch master glazes, or in a combination of thin, dark colors and thick, light colors. Any number of oil-based solvents, waxes, oils, and varnishes can be added to the paints or applied over them once the colors are dry, thus changing their physical properties.

Alkyd paints, which have an alkyd resin binder, can be thought of as fast-drying oil paints in that they mix with the same solvents—mineral spirits or turpentine—and can be used in combination with oils. Both paints remain wet for an extended period of time (although oils obviously remain wet longer) so colors can be blended together on the palette or the canvas without concern that they will dry too quickly. Like oils, alkyds can be applied to canvas or board in thick, opaque brushstrokes or in thin, transparent glazes.

While Winsor & Newton is the only major company currently offering a line of alkyd paints, several companies offer an alkyd medium that can be used to thin the alkyd paints or mixed with oils to speed up their drying time. Winsor & Newton makes a medium called Liquin, which is used in several of the demonstrations in this book; Gamblin Artists Colors manufactures two types of Galkyd medium, which have a more fluid consistency; and M. Grumbacher offers an alkyd medium that is useful in glazing colors or painting details.

For the painting shown on the page 19, I used a fairly traditional technique of first toning the surfaces of the panel with a light blue paint days before going out on location. The wash of blue reduced the absorbency of the gesso, making it easier to stroke the paint-loaded brushes across the surface and to quickly block in the elements of the landscape.

I followed the standard recommendation for working with oil paints (painting thin to thick) by starting with thin mixtures of dark colors and working toward thicker strokes of the light colors. Notice that some of the white and yellow paint is piled on to establish the bright sunlight.

Oil and alkyd paints can be mixed on the palette or right on the surface of the canvas or panel, and in cases where I wanted the colors lighter in value, I could work some titanium white or cadmium yellow light into the colors already on the surface. Likewise, a direct application of ultramarine blue or Prussian blue was worked into the sky to darken the upper regions.

As a way of demonstrating some of the physical characteristics of transparent watercolors, I did a small watercolor sketch using the Hudson River alkyd painting as reference material. The hallmark of a good watercolor is layering of transparent and semitransparent layers of color in a way that supports the compositional organization of the picture. That is, dull colors are applied in the shadows whereas vibrant colors describe the highlights.

To achieve that kind of layering, watercolorists need to know the physical characteristics of each color they intend to use. They should be aware that a cobalt blue is a nonstaining, transparent color whereas a phthalo blue is an intense, staining, transparent blue. One will perform quite differently than the other, and it is nearly impossible to keep painting one over the other until the desired results are achieved, as is possible with oils, alkyds, or other opaque paints.

In this watercolor version of the sunset, the texture of the paper itself comes through the overlapping washes of transparent color. I applied the paint, then blotted it to get the subtle transition to white where the sunlight was reflecting off the water. I needed thicker mixtures of the dark green in order for the paint to cover the purple background color, so I added very little water to a mixture of ultramarine blue and cadmium yellow medium.

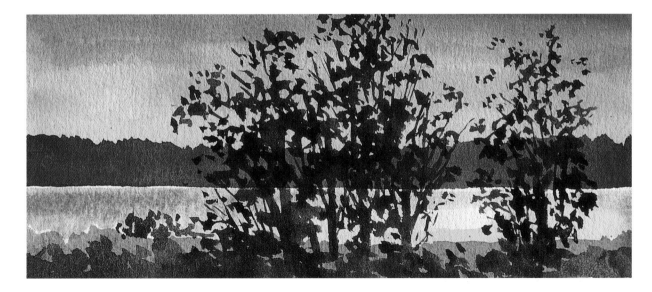

**WATERCOLOR
DEMONSTRATION**
3 x 7" (7.6 x 17.8 cm).

Gouache, Body Color, and Opaque Watercolor

These three paints are one and the same. *Gouache, opaque watercolor,* and *designer's colors* are names applied to the same commercially made paints, and *body color* is the term applied to transparent watercolors that have been mixed by the artist with opaque white watercolor paint (either Chinese white or titanium white).

The advantage of using gouache instead of, or in combination with, transparent watercolor is that one can apply light colors over dark. If you want to add sparkling highlights on the dark areas of a waterfall, white clouds in a blue sky, or reflected colors into the shadow of a building, gouache will allow you to do that even after you have painted the dark areas with a staining watercolor. Of course, gouache has a distinctly different look than the pure white highlights of unpainted watercolor paper, but you may not find that difference bothersome.

Commercial illustrators frequently use gouache because it is easier to change their pictures if an art director asks them to make an area of the illustration darker, lighter, or a completely different color.

To show how opaque watercolor compares with its transparent relative, I again painted the same landscape design, this time with Winsor & Newton gouache. Working on hot-pressed paper, I first laid in thin washes of color and gradually built up thicker applications of paint. In some cases I left hard edges around the painted shapes, and in others I allowed the wet paint to flow so that colors and shapes would blend.

**GOUACHE
DEMONSTRATION**
4 × 6¹/₂" (10.2 × 16.5 cm).

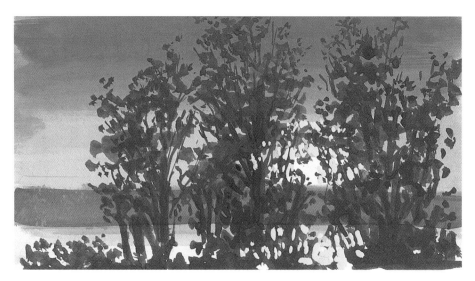

Acrylics, a twentieth-century development, are the newest—and the most versatile—painting medium. They can be applied to paper, board, canvas, and wood; they dry fast enough to allow an artist to build up many layers of paint; and they are opaque enough so that light-valued colors will cover dark ones. They are water-soluble, yet dry to a permanent finish. Liquid acrylic with the consistency of ink is available, as are high-viscosity varieties that are squeezed from a tube and can be applied in thick impastos.

The fast drying time presents a problem for artists who like to be able to manipulate opaque layers of paint for hours at a time, and the matte finish of the dried paint is not appealing to artists who like the luminous glow of oils. Manufacturers of acrylic colors would point out that one can add retarder to acrylic paints to slow the drying time and gloss medium to make the paints dry glossy. Nevertheless, there is a very different feel and appearance to acrylics.

Californian Marcia Burtt has adapted her equipment and procedures to be able to use these quick-drying, water-soluble paints outdoors, even at high elevations where the thin, dry air hastens the drying process. She squeezes the paints into the compartments of an air-tight fishing tackle box and periodically sprays them with clear water to keep them from drying out. She has a large container of water near her easel so she can clean the paint out of her brushes and moisten the acrylics as she mixes them.

ACRYLIC DEMONSTRATION
6¹/₂ × 8" (16.4 × 20.3 cm).

In this fourth painting of the sunset filtered through a grove of trees, I painted the sky and distant hills with thin washes of acrylic colors and the foreground areas with strokes of paint mixed with a thickening agent.

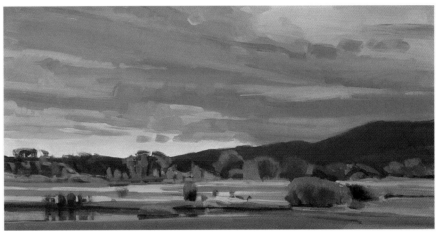

EVENING LIGHT, by Marcia Burtt, 1966
Acrylic, 15 × 30" (38 × 76 cm).

Burtt thins her acrylics nearly to the consistency of watercolors when she first blocks in the major elements of her picture, and then she applies them in thick brushstrokes as one might do with oil colors. She tends to leave forms broadly defined without fussing over details, thus emphasizing the abstract qualities of gestural brushstrokes and isolated patches of color.

Pastels

Many artists prefer pastels because they offer the most direct way of applying dry pigment to the surface of a painting. Some brands are hard and most appropriate for the initial stages of the painting process, while others are buttery soft and are best reserved for the final stages.

Unlike other paints containing mediums that bind them to a support, pastels depend on the texture of the paper or board to hold the particles of pigment. If an artist applies so much pastel that the textured surface becomes smooth, the support will no longer accept strokes of additional colors. That's why surfaces sold as supports for pastel have a distinctly rough texture so they can hold several layers of pigment.

Fixatives can be lightly sprayed over the surface of a pastel painting to bind the pigments to the support and add a texture to hold additional layers of pastel. Many artists choose not to use those fixatives because they will likely darken the colors and change the surface texture of a painting.

DAYBREAK, by Gil Dellinger
Pastel, 14 × 30" (35.6 × 76.2 cm).

The California artist Gil Dellinger often uses a long horizontal format for his pastel landscapes to emphasize the sweep of light at dawn or dusk. Using Wallis pastel paper or surfaces he prepares himself, Dellinger builds up layers of hard then soft pastel on the highly textured surface. Initially he blends the colors by rubbing them into the paper, but as the images progress, he allows each stroke of color to build on top of those already painted until they finally come together as a rich tapestry of tones.

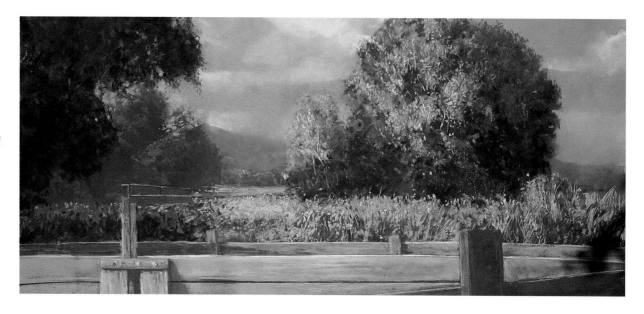

These four pictures, like several other groupings I've described earlier, illustrate the physical difference between painting media. In this case I've painted the same trellis overlooking the Hudson River that is a focal point of Wave Hill gardens in New York City.

I showed these demonstrations to a group of people attending one of my workshops, and they were more interested in the way I established the drawings underlying the paintings than they were in the fact that one was created in oil, another in acrylics, the third in transparent watercolor, and the last in pastel. Following is a brief explanation of that technique in case you might also find it helpful.

I took a 4- by 6-inch photograph to an office supply store and made a half-dozen photocopies of it, each time enlarging the picture and adjusting the degree of darkness. I left with some high-contrast, black-and-white photocopies that could be used like a compositional sketch of the scene.

I rubbed the side of a pencil across the backside of a photocopy that enlarged the photograph to the size of my intended painting. Then I taped the photocopy to the watercolor paper with the darkened backside held against the paper. When I traced the lines of the photocopy with a sharpened pencil, the lines transferred onto the watercolor paper, as shown here. That's a simpler and cheaper way of establishing a photographic image on a painting surface. It's not quite as accurate as projecting the image, but it works faster than using a grid system or a perforated cartoon drawing to transfer a drawing.

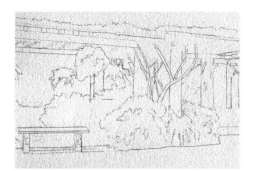

Preliminary drawing used for all four of the Wave Hill paintings.

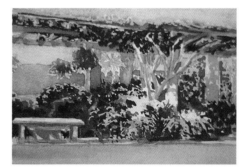

Transparent watercolor

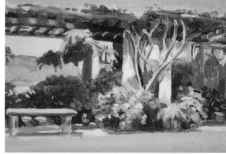

Oil

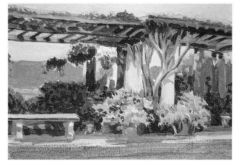

Acrylic

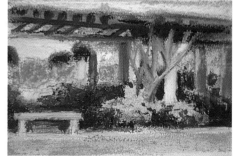

Pastel

Demonstration: BUILDING TEXTURE WITH DIFFERENT MEDIA

This series of paintings offers suggestions for using acrylics and watercolors for capturing the textural richness of rugged land formations. The subject is a view along the cliffside walk past the "cottage" mansions in Newport, Rhode Island.

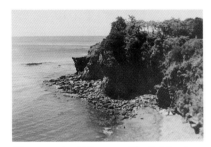

Photograph of Newport, Rhode Island, coastline used for this demonstration.

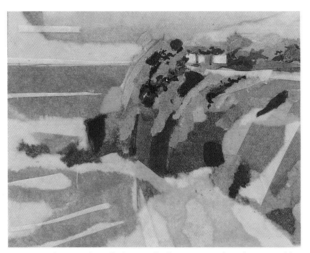

Using techniques handled expertly by artist and author Gerald Brommer, I first painted sheets of rice paper with transparent watercolors and allowed them to dry. I then cut a 3 ¹/₂ × 4 ¹/₂" piece of light blue rice paper and glued it to illustration board using acrylic matte medium as an adhesive. On top of that I glued additional pieces of torn, tinted paper, trying to follow the pattern of colors and values I observed in the photograph of the scene. Matte medium is a great adhesive to work with, as it is archival and dries permanently, allowing an artist to apply acrylic paints over the collaged surface.

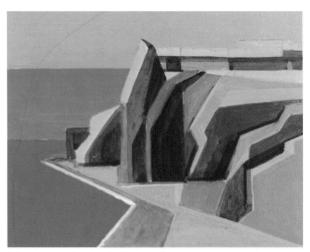

To achieve a flat, hard-edged landscape, I put strips of tape around each shape I wanted to paint and then sealed the edges of the tape with acrylic matte medium to keep the paint from seeping underneath. I then painted two or three layers of acrylic paint in each shape to build up the opacity of the color without incurring any obvious brush marks. After the paint dried in each section, I removed the tape around it and applied tape around the edges of other shapes.

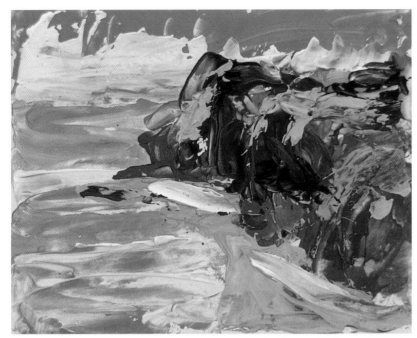

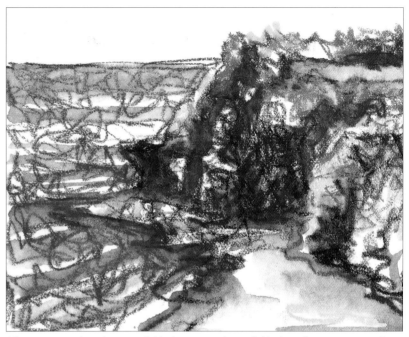

Most manufacturers of acrylic paints make a variety of additives which can change the physical appearance, drying time, and finish of the paints. In this demonstration I used some Golden Heavy Body medium to give the paints the consistency of heavy paste and used a palette knife to apply thick strokes of those mixtures onto the illustration board.

There are a number of water-soluble drawing tools available that allow artists to make a drawing and then convert the lines of the drawing to washes of color. In this demonstration I first made a quick gestural drawing with Schwan-Stabilo water-soluble pencils and then brushed over the lines with clear water to create transparent washes in some areas. I then rubbed the pencils into areas of the paper that were still wet as a way of intensifying the tones in the shadow areas of the scene.

Palettes of Color

These charts show the most commonly used colors in landscape painting—greens. They illustrate the variety of greens that are available either straight from the tube or made from combinations of blues and yellows. One chart shows transparent watercolors while the other shows oil paints.

I would recommend that you try out some of these tube colors and combinations so you become familiar with those that are perfect for dark, shadowed areas of trees and bushes; the ones that will help you separate bluish-green evergreens from the surrounding oaks and maples; and the bright yellow/greens that you'll want for the sunlit branches around the edges of large trees.

There are a variety of combinations of oils and watercolors that you'll become familiar with as you observe other artists painting. If you add a third paint to the combinations I've used, you'll be able to push the greens to lighter, darker, warmer, or cooler tones. And then you'll come across unexpected combinations like mars black and cadmium yellow light.

As you study the work of other landscape painters in museums, in workshops, or on painting outings, you'll note that everyone develops a preference for certain colors. I've been with some landscape painters who rely heavily on the earth colors—the siennas, umbers, and ochres—and avoid the brilliant cadmiums and phthalos. They like to keep their colors warm and thin, with subtle suggestions of the greens and blues in the landscape, much like the great painters of the early nineteenth century who didn't have many high-key colors available to them.

I've also observed painters who build their pictures with the vibrant phthalo greens and blues, deep cadmium yellows, and brilliant reds. Their choices help to create lively pictures with a decidedly contemporary feel to them.

In addition to these differences in color choices, the artists I've learned from have gone from the extreme of working with only three or four tube colors to those who squeeze out twenty or twenty-five small blobs of paint around the outside of a large wooden palette.

The point I want to emphasize is that although each of these artists was convinced that his or her choices were "the best," all of them were capable of producing outstanding landscape paintings: the differences in style did not affect quality. It became clear to me that the only rule one should follow in choosing a palette of colors is that the final selection be one that allows the artist to express his or her unique point of view.

CHART OF TUBE GREEN WATERCOLORS

Viridian

Hooker's Green Dark

Permanent Green Light

Chrome Oxide Green

Phthalocyanine Green

Sap Green

CHART OF MIXED GREEN WATERCOLORS

Aureolin + Cobalt Blue

Cadmium Yellow Medium + Cobalt Blue

Cadmium Yellow Medium + French Ultramarine Blue

Cadmium Yellow Pale + Cobalt Blue

Phthalocyanine Blue + Cadmium Yellow Medium

CHART OF TUBE GREEN OILS

Phthalocyanine Green

Phthalocyanine Green Yellow Shade

Chromium Green Oxide

Viridian

Permanent Green Light

CHART OF MIXED GREEN OILS

Holbein Compose Green No. 2

Holbein Compose Green No. 4

French Ultramarine Blue + Yellow Ochre

French Ultramarine Blue + Cadmium Yellow Medium

Cobalt Blue + Cadmium Yellow Medium

CHART OF MIXED GREEN OILS

Cobalt Blue + Cadmium Yellow Light

Phthalocyanine Blue + Cadmium Yellow Ligh

PLANNING YOUR APPROACH

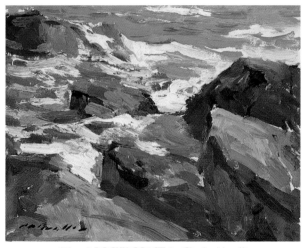

(Above) ROCKY COAST, by Charles Movalli
8 x 10" (20.3 x 25.4 cm).

(Opposite) CROTON RIVER, 1992
Gouache on tan Arches paper, 12 x 18" (30.5 x 45.7 cm).
Collection Mr. and Mrs. C. W. Doherty, Sr.

The painter John Singer Sargent (1856–1925) is reported to have said that he could be dropped off at any location and he would be able to paint a decent landscape at the site. That may have been true of the extraordinarily gifted Mr. Sargent, but most artists spend a considerable amount of time walking through fields, hiking along trails, and driving down country roads and along scenic coastlines searching for the best combination of natural and manmade objects illuminated by the most interesting pattern of sunlight and shadow.

One Artist's Approach: Charles Movalli

There is no one who is better known to the readers of Watson-Guptill books or *American Artist* magazine Charles Movalli, a painter, teacher, and writer from Gloucester, Massachusetts. I asked him to write a few words about his approach to landscape painting and allow me to reproduce one of his oil paintings in the book (see *Rocky Coast*, on page 31). Here is what Movalli has to say about his work:

When you paint in New England, you have variety: there are the subtle colors of spring, the stark contrasts of winter, the gaudiness of fall. When you tire of dry land, you have the ocean. And the seacoast towns combine landscape, water, and architecture. So you couldn't ask for much more.

I don't like to get too "close" to the subject. That is: Viewers should know what I'm painting, but I don't want to spoon-feed them. I'll forgo detail, textural niceties, even accuracy of drawing if they get in the way of my recording the big facts about a subject. Sometimes it's hard to determine what these big facts are. A location can be so visually stimulating—and it's a painter's job to be visually stimulated—that it's almost impossible to settle on a theme. One advantage to painting for years in the same area is that you slowly work through the obvious facts— the subject's "picturesqueness"—and get under the things that most strike a tourist. When you travel to new spots, on the other hand, you are a tourist: so the problem is to take advantage of the stimulation of the new without being overwhelmed by it.

I do a lot of work on the spot and so use a simple palette and simple materials—anything to lighten the load. A limited number of colors forces you to mix and thereby analyze what you see. In addition, a limited palette is harmonious, since your colors are more closely related.

In composing the picture, I try to isolate the basic movements of the landscape—just as you do in a "gesture" drawing of a figure. If I can find the half-dozen basic lines and directions that make up the scene, I'm half-way there. It's like deciding the agenda of a meeting: what counts most; what, second; what, third. I sometimes lay my darks in with a thin warm wash; other times, I draw a few lines and start directly with color. Sometimes I like a colored ground; sometimes, white canvas. I'm still experimenting. The amount of finish also varies with the subject and my mood. I don't like well-done—but will fluctuate between medium-rare and sushi. I most often prefer the last—but end up with the second. The picture's done when I've said all I want to say about the subject. I avoid having an "ideal" of finish, some kind of standard that might circumscribe my freedom in handling the material. The aim is to know what you're after, but in a broad sense so you can have fun along the way. The picture has to have a chance to talk back to you. Half the fun is seeing how one line reacts with another; how one color suggests another; how one shape leads to another. So that as you paint, you're searching and finding at the same time.

Nothing polarizes artists as much as the question of whether or not it is acceptable to use photographs as source material for making paintings. Some are adamant in their belief that using photographs is cheating, or at least accepting a distorted view of world; while others believe just as strongly that the camera is a legitimate means of processing information. In the end, the only right or wrong about photographs is whether or not they help you accomplish your objectives as an artist.

The two most important things to remember if you work from photographs are that the camera takes in whatever is within range of its lens—nothing more and nothing less—and that photographic film will exaggerate the colors and range of values in a landscape. That is, shadow areas become darker, mid-tones become lighter, and colors shift to blue or red depending on the type of film you use. Knowing that, you might want to take a number of photographs of a subject, changing your focus and the speed of the exposure with each picture. That way you'll have more information to use when composing and painting your landscape.

As a comparison between what an artist sees and what a camera records, I show you a picture of a church in Charleston, South Carolina, that I painted as the sun was setting and a photograph of the same church. Without being too concerned for the accuracy of the architecture, I sketched in the basic composition while waiting for the light to change, and then I painted furiously during the fifteen minutes when the golden light on the church contrasted with the cool grays on the gravestones. It was only later, when looking at photographs of the church, that I realized how distorted the proportions were in my painting. The building was not symmetrical, the scale was not accurate, and the gravestones I painted were much larger than they were in the snapshot. Yet the point I want to make is that the "true" proportional relationships were not important to conveying the feeling I had while watching the sun climb from the gray headstones up the columns of the church.

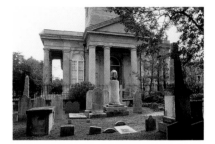

Photograph of the cemetery and church in Charleston, South Carolina.

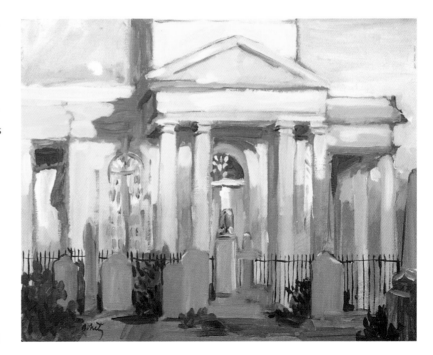

The Completed Painting: CHARLESTON SUNSET, 1994 Alkyd, 11 × 14" (27.9 × 35.6 cm).

Sketchbooks

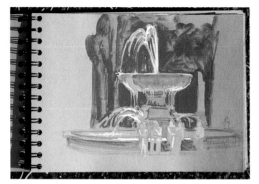

Sketch of a fountain on brown paper with sepia ink and white gouache. 7 × 9" (17.8 × 22.9 cm).

Pencil sketches of two New York City landscapes. Individual sheet size: 5¹/₂ × 8¹/₂" (13.9 × 21.5 cm).

Watercolor sketch of an English cottage in an American Journey sketchbook. 9 × 12" (22.9 cm × 30.5 cm).

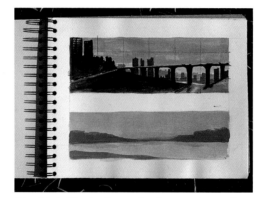

New York City landscape sketches, now in acrylic on Rising's Stonehenge cream-colored paper. Individual sheet size: 9 × 12" (22.9 × 30.5 cm).

As a student of painting, I've always been fascinated by the sketchbook drawings other artists have made because those tell me so much about the process the artists went through in realizing their paintings. I see the various compositional ideas they considered, the notations they made about important colors and atmospheric effects, and the studies of various elements that eventually came together in the finished picture.

The choice of materials used for the sketches also tells me something about the artists' orientation. If they smeared rich, black charcoal on a soft sheet of paper, erasing out the highlights and rubbing in the mid-tone values with their fingers, then I know the artists were thinking of the strokes of paint that would come together in their paintings. If they drew sharp, crisp lines on laid paper to define their landscapes, then I understand they were striving for a detailed rendering of the landscape in their paintings. One set of materials lends itself to a loose, painterly style of drawing, the other to a precise, linear style. The pages of my own sketchbooks are shown here to illustrate a variety of materials and techniques that I have used to record various subjects and make plans for using those records to compose larger studio pictures.

MAKING A SERIES OF SKETCHES

The two horizontal pencil sketches on the opposite page were made while I was riding a commuter train out of New York City. I tried to record as much information as I could about scenes I had been observing over several days—one a series of elevated roadways supported by interlocking arches and the other a railroad bridge spanning the intersection of the East River and the Hudson River.

A few days later I made color sketches of each subject using only three tubes of acrylic paint: alizarin crimson, French ultramarine blue, and titanium white. By limiting my palette I thought it would be easier to try out different ways of presenting each subject, especially since they were both rather gray winter scenes.

For the purposes of this book, I decided to try out five compositional formats for the railroad bridge picture, all of which are reproduced here. All five were done with acrylic paints on paper. In the first of these painted studies, the elements are placed within a circle, in the second within an elongated vertical space, in the third within a square format, in the fourth within a long horizontal space, and in the fifth within a rectangle with curved edges along the top. You'll note that in each case I adjusted the shape and

size of the landscape elements so they would fit more comfortably within the chosen space. For example, curved edges were emphasized in the circular picture, shapes were elongated in the vertical space, and forms were stretched in the long horizontal. In the end, I liked the long horizontals best because they put the bridge into a more interesting and complete space.

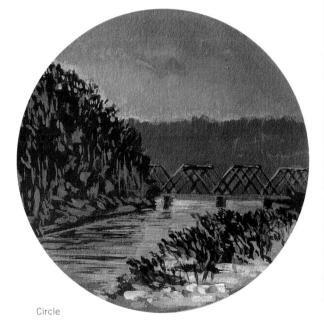

Circle

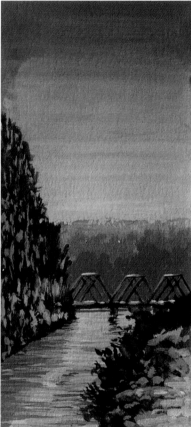

Elongated vertical space

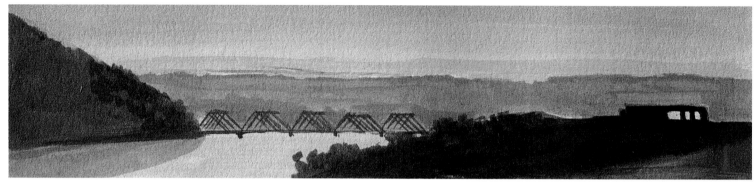

Long horizontal space

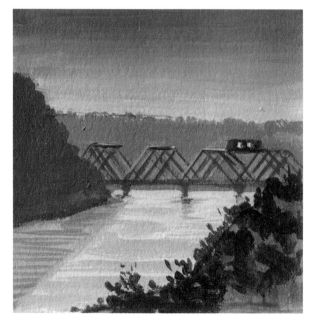

Square

Rectangle with curved edges along the top

FROM LOCATION TO STUDIO

Small paintings done on location can easily be used as the basis of larger studio pictures, especially when you are dealing with a scene that changes so rapidly that you can make only a quick study of its appearance. For the sketch of the Mississippi governor's mansion shown here, I stood along the fence surrounding the property and painted a quick study of the lights both inside and outside the mansion. (The governor was hosting a dinner for Pat Buchanan, a presidential candidate at the time, and security guards at the mansion were nervous about the scruffy-looking guy standing along the fence with a contraption that looked to them like surveying equipment. I made life easier for both of us by finishing my painting in about seventy-five minutes.)

When you enlarge an image from a sketch to a canvas, there is an opportunity to carefully consider the formal arrangement of compositional elements, the amount of detailing, and the overall mood of the picture. The freshness and spontaneity of the sketch are replaced by a studied, refined evaluation of the subject. This need not be a liability. Although some enlargements fail to maintain the vitality of the original sketch, others strengthen its weaknesses.

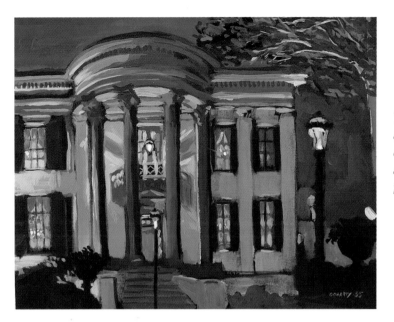

GOVERNOR'S MANSION, JACKSON, 1995
Alkyd, 11 × 14"
(27.9 × 35.6 cm).
Courtesy Bryant Galleries, Jackson, Mississippi.

This painting, which was done on location in the early evening, was used as the basis of the studio painting below it.

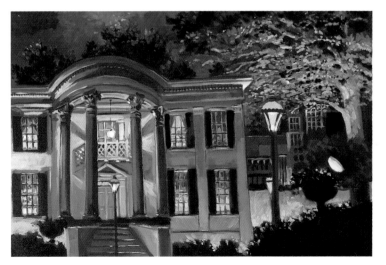

GOVERNOR'S MANSION, JACKSON, 1995
Alkyd, 20 × 30"
(50.8 cm x 76.2 cm).
Courtesy Bryant Galleries, Jackson, Mississippi.

Stages of Painting

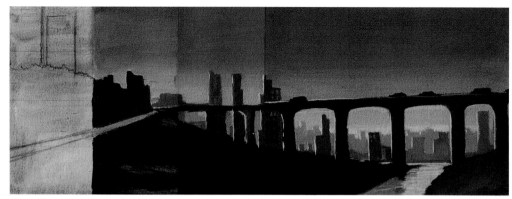

This illustration shows the progressive stages in the development of the painting, starting from the pencil sketch on the gessoed surface at left and ending with the finished sections at right.

An acrylic painting demonstration showing how paints can be mixed with large amounts of medium and applied over a grisaille (gray painting) in glazes. 4 × 7 1/2" (10.2 × 19 cm).

As another exercise, I painted an oil sketch of the elevated roadway in stages so you can see how it progressed from a pencil drawing on a surface toned with burnt sienna through glazes of blues, umbers, and pinks to a more finished sketch. To make the glazes, I mixed oil paint with Liquin alkyd medium so the color would be transparent and fast-drying. You'll note that in the beginning stages, an oil painting can be loosely painted in thin glazes of color. As the picture progresses, an artist can refine edges, balance colors and values, and build up the thickness of the paint.

UNDERPAINTING

The painting shown at the left was done with acrylic paints, but it illustrates a technique that is frequently used with oils and alkyds. The scene was first painted with mixtures of black and white paint to create a grisaille, or gray painting. After the grisaille dried, I applied glazes of color made by thinning yellow, orange, red, and purple acrylic paints with water and generous amounts of acrylic matte medium.

One reason artists use this technique is so they can first resolve the composition of values and then deal with the issue of color. Another is that the procedure makes it easier to get a very smooth, polished surface on the finished painting. A third reason is that it allows the artist to work with thin, luminous veils of color rather than thick, opaque strokes of paint.

There are a number of ways of painting a grisaille, some of which involve using completely different paints for the grays than one plans to use for the glazes. For example, the grisaille could be painted with fast-drying alkyds and overpainted with oils. The grays could also be developed in India ink, egg tempera, or egg-oil emulsion and then overpainted in oils after the grisaille has thoroughly dried. If you are interested in these methods, you should do some independent research to find the complete recipe other artists have used because an improper combination of materials could have disastrous results. (I should note that the answer to a question I am frequently asked—whether it is advisable to create an underpainting in acrylics and then overpaint in oils or alkyds—is no.)

At times you may want to underpaint a scene in two or three warm-and-cool or light-and-dark colors to quickly fix the pattern of sunlight and shadow, to push the range of values to the extremes, or to shift the overlaid colors toward a particular color range. Here I used alkyds to underpaint the strong, dark shadows with a cool purple and the sunlit areas a warm golden white. That fixed the pattern of shadows, which would change as I refined the picture over a two-hour period, and it forced a strong contrast between the values. The alkyds dried rather quickly on the hot, dry day, and I was able to overpaint immediately with oil colors.

Shown here is the underlying wash of cool dark purple, with warm yellow used to block in the pattern of sunlight and shadow and to push the contrasts in values.

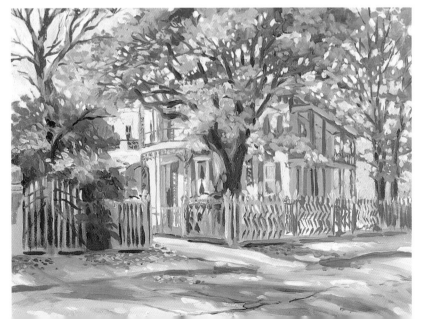

The Completed
Painting:
**GARDEN
DISTRICT
SUNLIGHT, 1996**
Alkyd and oil,
11 × 14"
(27.9 × 35.6 cm).
Courtesy Bryant
Galleries,
New Orleans,
Louisiana.

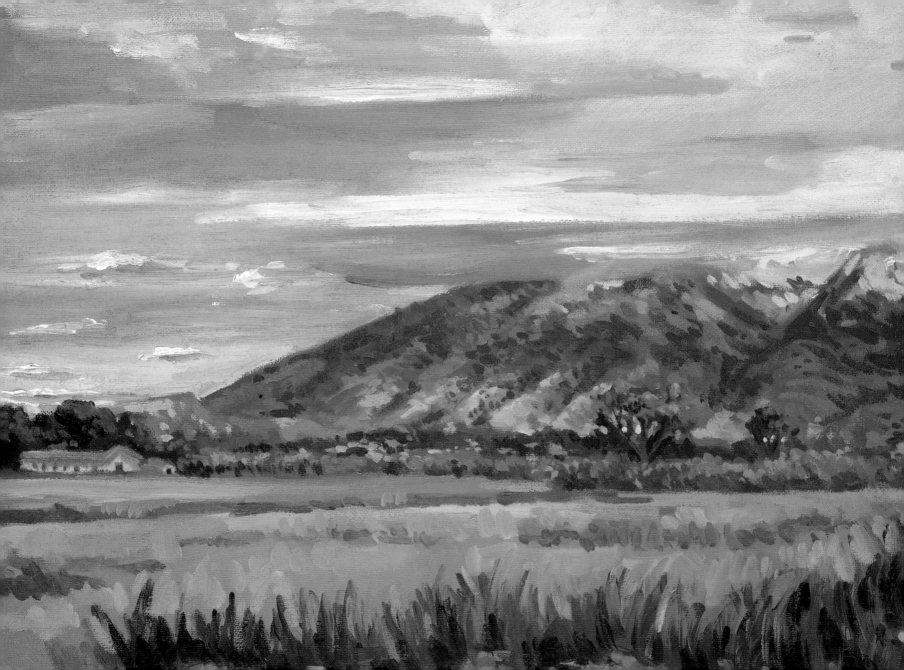

LAND

(Above) ONEONTA LANDSCAPE, 1996
Oil, 20 × 24" (50.8 × 61 cm).

*For this painting, done on gessoed canvas, I followed one of the
basic tenets of realist painter Jack Beal, the idea that land
formations should bend and turn, creating a sense of vitality
through their movements. I blocked in the initial shapes with
alkyd paints, and later used a mixture of cobalt blue with a
generous amount of Liquin alkyd medium to put a cool wash of
color over the left side of the painting.*

(Opposite) TRINCHERA RANCH HOUSE
AND MOUNT BLANCA, 1996
Alkyd, 12 × 16" (30.5 cm x 40.6 cm).

Land formations serve as the armature on which artists build the sculptural
shapes of their paintings. Whether you are presenting snow-covered mountains,
plowed fields, or rocky shorelines, you are working with the flat, round, shallow,
or deep structure of the landscape. Everything else in the painting is positioned
according to those basic land formations. The small trees climb distant ridges
of the mountain, clouds float above the plains, and bathers punctuate the sweep
of the beaches.

This chapter offers a variety of land formations, from bending, turning
meadows to the vast spaces and rugged terrain of the Southwestern United
States. Most of them illustrate how hundreds of acres of land can be recorded
within the borders of a small canvas.

Distinguishing High Altitudes

Vegetation becomes thin and rugged when you reach high altitudes, and the challenge of painting at those heights becomes one of giving land formations the right sense of scale and distance. One way of establishing the distance is to mix a small amount of blue with every color you apply to the paper or canvas so it will be slightly muted, as if covered by veils of moisture.

Also, the shadows need not be as dark or sharply defined as they would be if you were describing nearby rocks and trees. You can easily soften the edge between a highlight and a shadow by dragging a clean, soft brush from one area to the other, allowing the tones to mix and the edge to become blurred. One artist I know uses wads of facial tissue to break up the line between two sharply different values.

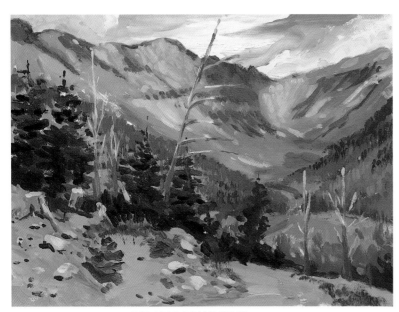

COLORADO LANDSCAPE, 1996
Alkyd, 11 × 14" (27.9 × 35.6 cm).

I used relatively light values to push the mountains into the distance and sharp contrasts to pull the foreground objects close to the viewer. I also painted the dead tree diagonally across the mountains to emphasize the difference in scale.

AMARILLO LANDSCAPE, 1994
Alkyd, 11 × 14" (27.9 × 35.6 cm).

Here the sharp pattern of sunlight and shadow suggested the monumentality of the canyon walls.

Colorado artist Clyde Aspevig is one of the most extraordinary landscape painters I have ever had the privilege of observing. Before he even begins to paint, he visualizes the picture in his mind and determines how he will present the most interesting aspect of the light, color, shape, or pattern in the landscape. With that plan in mind, he outlines the major shapes with thin mixtures of oil paint and begins to establish the center of interest with jabs of oil paint from the edge of a flat brush.

As Aspevig builds the surface of his painting, shapes are simplified to the point that a grove of trees becomes one large block of olive green, an embankment becomes one broad stroke of burnt sienna, and a distant mountain is reduced to a band of muted purple. Colors may be added to enrich these simple forms, but Aspevig avoids getting sidetracked by details until the composition is nearly complete. Even then, there is a minimum number of small brushstrokes defining a few branches, ripples, or rocks.

MOUNT LINDSEY (Study), by Clyde Aspevig, 1996
Oil, 10 × 12" (25.4 × 30.5 cm).

MOUNT LINDSEY, by Clyde Aspevig, 1996
Oil, 20 × 24" (50.8 × 61 cm).

UTE CREEK DRAINAGE (Study), by Clyde Aspevig, 1996
Oil, 12 × 16" (30.5 × 40.6 cm).

Simplifying Monumental Shapes

Diana Horowitz goes even further in simplifying monumental forms, editing the colors and objects that she observes into a few basic shapes defined by colors in a limited range of values. All of this happens on a very small scale, with Horowitz painting and repainting land shapes on canvases and panels as small as 6 by 8 inches.

Because she is so particular about the relationship of the simplified forms in her landscapes, Horowitz will return to a site several times and reconsider everything she has already established in the picture. Even small paintings may take her several weeks or months to complete because she repaints major shapes, refines edges, changes the light source, or eliminates details until she feels she has the right balance of elements. Her decisions are intuitive and she continues to make changes until everything "feels" right.

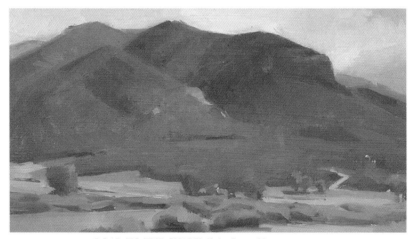

ROAD TO THE CHAPEL II, by Diana Horowitz, 1996
Oil on panel, 5 × 9" (12.7 × 22.9 cm).

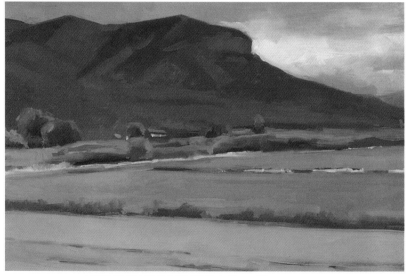

VIEW FROM THE LODGE II, by Diana Horowitz, 1996
Oil on panel, 8 × 12" (20.3 × 30.5 cm).

Understanding Atmospheric Perspective

Working in the great tradition of the French and American Impressionists, Arizona artist Curt Walters carries large canvases out into the landscape—often perching his easel on a windswept ledge overlooking the Grand Canyon—and paints what he observes with quick brushstrokes of thick oil paint. Because he often paints the vast spaces of the American Southwest, Walters has to modify his palette of colors to create the appearance of distant land and sky formations. Purples and blues dominate the background mountain ranges, while crisp ochres, yellows, and greens bring the foreground into sharp focus.

The rule of thumb in landscape paintings is that as things recede in space they become more blue in color and less contrasting. In mixing colors to paint a distant mountain, you might start with a large amount of titanium white and add touches of Prussian blue, French ultramarine blue, or cobalt violet. If you perceive a tinge of green or brown in those far-off planes, a little bit of yellow ochre or burnt sienna may be just enough to bend the blue tint in those directions. If you then want to paint mountains that stand in front of the ones you've just painted, a small addition of the same blue, ochre, or burnt sienna will be enough to darken the paint to match the closer forms.

As you can see from Walters's painting, patches of color will blend together in the viewer's eye to create a unified picture, so you can leave impressionistic strokes of thick paint on your canvas and not feel obliged to paint smooth, detailed representations of everything you observe.

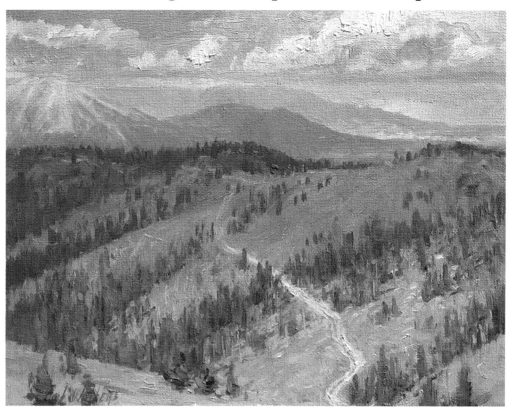

THE HIGH ROAD, by Curt Walters, 1996
Oil, 11 x 14" (27.9 x 35.6 cm).

CHAPTER 5

TREES

There are two main concerns when trying to establish the distance, scale, and types of trees within a landscape: shape and color. A tall, skeletal form painted with dark blue and green colors is quickly identified as a pine tree, while wide, dense, arching shapes painted in varying shades of yellow and green will suggest a maple tree. The lighter and bluer the shapes and the less distance there is between them, the more the trees will appear to be in the background of the landscape.

(Above) VERMONT LANDSCAPE, 1995
Alkyd, 11 × 14" (27.9 cm × 35.6 cm).

Because there was so little foliage, the trees in this landscape created a pattern of vertical lines broken up by patches of sunlight and shadow. Notice how the snow hanging on the limbs and surrounding the trunks helps to define the shape of these winter trees.

(Opposite) CALIFORNIA WHIRLPOOL LANDSCAPE, 1993
Alkyd, 11 × 14" (27.9 × 35.6 cm).

To paint these sharp-edged palm leaves and crusty trunks, I used thick strokes of paint to block in the shapes and then scraped lines through them with the back end of my brush.

The Color Green

The challenge here was to find the right shapes and colors to capture the appearance of the trees and the sense of distance across the lake. I answered the challenge by turning the trees into a complicated pattern of green leaves and light blue sky and blending together the greens and browns of the distant shoreline. Most of the greens had a yellow tone to them because this was a summer afternoon.

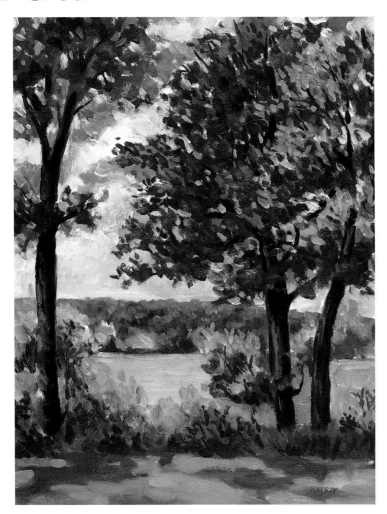

Most of the landscapes you'll find yourself painting will rely on a well-developed selection of greens. You'll find a great difference of opinion among artists on how to handle the color green. Some will have a wide array of tube greens on their palette, including such pigments as viridian, permanent green light, Hooker's green dark, compose green, phthalocyanine green, and chromium green oxide. The reason for buying all those different greens, the artists will argue, is that each has its own physical characteristics that make it appropriate for certain specific painting applications. Viridian is a bright, transparent color that works well for watercolorists who like to lift color from the paper, while chromium green oxide is a flat, matte green that is perfect for the shaded grass under a tree.

When you look at the palettes of colors used by other artists, you may very well find they don't contain any tube greens at all. Why? Because those artists prefer to mix their greens from combinations of the same colors used for the ground, sky, trees, and rivers. The bright leaves at the top of the tree might be painted with a combination of cobalt blue, titanium white, and cadmium yellow light, while the dark leaves in the shadowed lower portion of the trees will be established with a combination of French ultramarine blue and yellow ochre.

While both of these groups of artists can make strong cases for why their methods are preferable, in the end the only correct answer to the question of whether to use tube colors or mixtures is: What works for you?

ROCKEFELLER PARK, 1995
Alkyd, 11 × 14"
(27.9 cm × 35.6 cm).

The most important aspect of this scene was the stark contrast between the dark greens in the foreground and the shaft of light just at the crest of the hill leading down to the river. I worked on a panel toned with burnt sienna so the initial greens would appear darker on top of the complementary red color. After blocking in the arching shapes of the leaves, I used thick mixtures of blue (titanium white + cobalt blue + Prussian blue) to punch small holes in the masses of green and make the trees become believable shapes within the landscape.

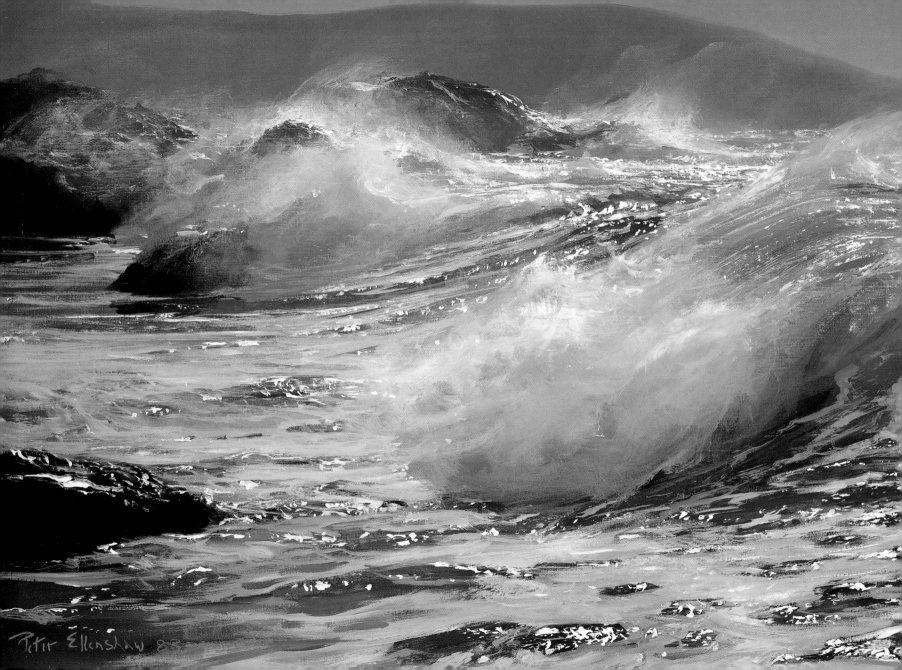

Peter Ellenshaw 83

WATER

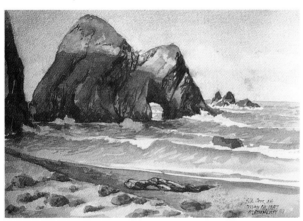

(Above) ELK COVE, CALIFORNIA, 1987
Watercolor, 7 × 10" (17.8 × 25.4 cm).

In this watercolor sketch, I applied several layers of paint to the dark, shadowy forms of the rocks and used only a few strokes of transparent color to establish the waves coming toward the shoreline.

(Opposite) BIG SUR (detail), by Peter Ellenshaw, 1989
Oil, 24 × 48" (61 × 121.9 cm).
Courtesy Mill Pond Press, Venice, Florida.

Oil was the perfect medium for this painting because it could be built up from the thin, dark shapes to the thick, opaque areas of foaming water; and remain wet long enough for the artist to swirl the blues and greens together into an endless pattern of rushing waves. Note how the sparkling highlights add an extra dimension of realism to the painting.

Lakes, streams, creeks, rivers, waterfalls, and pools of water are deservedly popular subjects for landscape paintings. They can open up the space between tight groves of trees, create intriguing reflections of sky and land, establish curving edges to help with a composition, and provide the opportunity for varied brushstrokes. Indeed, if you are unfamiliar with a location and don't know where to set up your easel, head for the water and you're sure to find something worth painting.

Some water formations are easier to deal with than others. Oceans are often so vast that one has to include a good part of the shoreline in order to keep the picture from getting boring. The nineteenth-century painters John Frederick Kensett (1816–1872), William Trost Richards (1833–1905), and Stanley William Haseltine (1835–1900) understood that need and painted detailed piles of rocks along the shorelines of their paintings of the Atlantic. Albert Bierstadt (1830–1902), on the other hand, included crashing waves in the foreground of his expansive views of the ocean.

Sometimes the best way to capture the sense of motion and light in water is to spend more time painting the dark, detailed forms along the shoreline than the water itself. By framing the water with rocks, dark skies, islands, or beaches, it will take only a few strokes of fluid watercolor to establish the appearance of a lake or ocean. That was the technique I used for the watercolor sketch shown here of a beach along the Pacific ocean near Elk Cove, California. The sense of light delicacy in the water is enhanced by the contrasting dark shadows on the rocks.

Documenting Reflective Transparencies

Most bodies of water are like sheets of glass that either reflect the colors around them or reveal the colors below their surface. One's perception of the water depends on the angle of view, the roughness of the water's surface, and the amount of light within the landscape. In the early morning, a lake may appear as a sheet of gray slate; on a calm sunny day it will become a polished mirror; and on a stormy evening it shows alternating stripes of black and gray. The accompanying paintings show how various combinations of transparent watercolor can be used to paint those reflective, transparent forms.

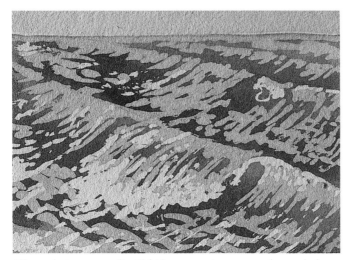 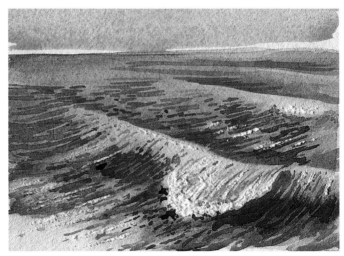

Watercolorists can use liquid frisket as a resist agent much as melted wax is used to batik fabric. Here I applied frisket everywhere I wanted to preserve the white of the paper, allowed it to dry, and then flooded the paper with a wash of aureolin yellow. When the wash dried, I blocked out more of the image with liquid frisket and applied a wash of rose madder genuine. Although most pigments used to make watercolor paints have some degree of staining power, there are a few nonstaining colors, and these can easily be lifted from the paper to soften edges or lighten values. A third wash of transparent, nonstaining watercolor used in a similar fashion was cobalt blue. Because the colors are nonstaining, I could continue by softening edges and lightening tones.

In this case, I used staining, transparent colors like Winsor yellow, Winsor red, and phthalo blue to paint waves approaching the shoreline so I could maintain the light, transparent appearance of the water while still suggesting the shadows cast by the overhanging waves. I used a utility knife to scratch white lines into the dried paper to bring back some of the highlights.

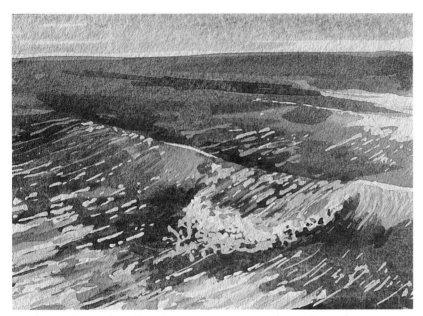

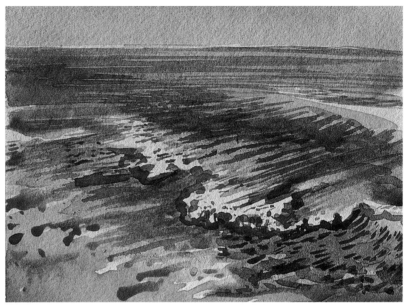

Working with a similar palette of staining, transparent colors and one sedimentary color (French ultramarine blue), I painted the same waves. After the watercolors had dried, I mixed cobalt blue with opaque white gouache and painted the bright highlights on the crest of the waves and the trailing, light-blue foam. Notice how different the gouache looks from the frisket-preserved whites.

I began painting this scene with transparent, staining colors and then worked over those with sedimentary colors such as French ultramarine blue and Rembrandt's transparent oxide red. I also dampened the paper in certain areas and scrubbed off some of the paint, leaving faint suggestions of the staining colors.

GOLDEN BEACH,
by Nita Engle, 1988
Watercolor, 16⅞ × 28⅛"
(43 × 71.1 cm). Courtesy Mill Pond
Press, Venice, Florida.

*Michigan artist Nita Engle has a
remarkable ability to capture the
appearance of water with a limited
palette of transparent watercolors.
She does a pencil drawing of
the major shapes in a landscape,
blocks the areas intended to remain
white by covering them with liquid
frisket, and then pours mixtures of
transparent, nonstaining colors
over the watercolor paper to create
wet-in-wet blends of colors. After
removing the frisket, she may
soften edges or add tints of color to
the negative shapes, depending on
the balance of positive and negative
shapes she wants to maintain.*

*You'll note that in this painting
of reflections in the shallow waves
along a beach, Engle has used
thin blends of colors, confined by
the pattern of white waves, to
capture the mirror-like surface of
the water. If she had used thick,
opaque mixtures of watercolors or
tightly detailed brushstrokes, she
wouldn't have achieved the same
light, transparent effect that is
so characteristic of water along
a beach.*

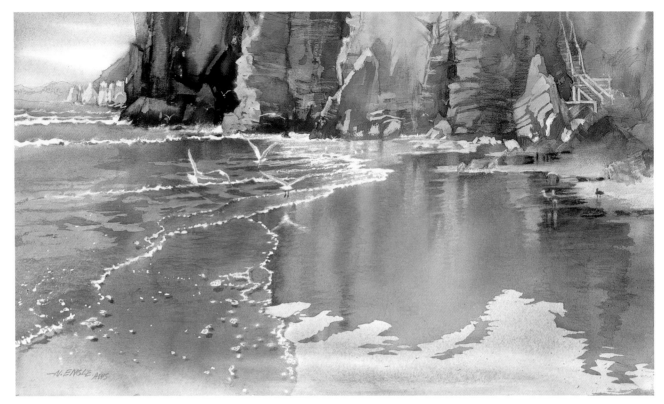

Shallow water in a stream weaves its way between rocks, creating rippling lines and foamy curves through the landscape. *Turn in the Creek* was done in gouache on a sheet of soft, tan-colored Arches printmaking paper. I first painted the white highlights of the flowing water, then the dark linear ripples, and finally filled in the middle tones and details.

Because gouache can be applied in either thin, transparent washes or thick, opaque brushstrokes, it can be painted on papers such as this which have a medium value—in this case tan. Here I gradually covered up the tan color, painting dark values over light and light values over dark.

In contrast to the gouache painting, the picture below of a shallow swimming area shows the effects that can be achieved by stroking thick alkyd paint with a bristle brush to create the lines of a rippling river.

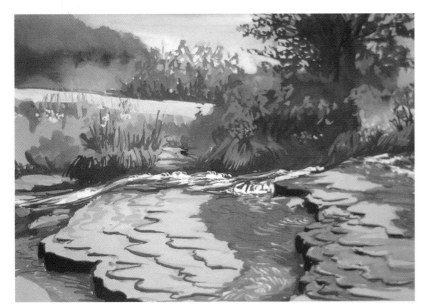

TURN IN THE CREEK, 1991
Gouache, 10 × 14" (27.9 × 35.6 cm).

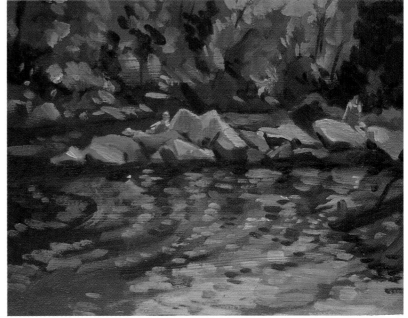

CROTON SWIMMING HOLE, 1992
Alkyd, 11 × 14" (27.9 × 35.6 cm).

Capturing Waterfalls

After sketching in the basic forms, I blocked in the darkest darks with a purple made from Prussian blue and alizarin crimson.

A wash of burnt sienna, titanium white, and yellow ochre established the lighter areas of the scene.

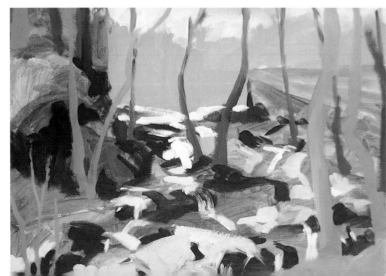

Waterfalls can be troublesome elements of a landscape because they tend to look either frozen or filled with frothy detergent. I've done a couple of paintings of a waterfall in spring and summer to suggest ways of making the water appear to flow through a cascade of rocks, kicking up white foam along the way. I've also included a few pictures of streams and rivers to show how each of those subjects might be handled.

In painting the waterfall in the spring, I first sketched in the outlines of the rocks with a thin mixture of purple (Prussian blue plus alizarin crimson) to be sure I could fit the most interesting parts of the waterfall onto the small (9- by 12-inch) Gessobord. Next I put a wash of deep gray (Prussian blue, alizarin crimson, burnt sienna, and titanium white) in the shadow areas, because I knew the scene would be convincing only if I emphasized the pattern of sunlight and shadow created by the large boulders on the left side of the waterfall. I also put a light tone of tan into the sunlit spaces and light blue into the sky.

With that as a base to remind me of the pattern of darks and lights, I continued to deepen the shadows and lighten the lines of rushing water. Only in the

last stages of the painting process did I add thick brush strokes of light green for the leaves and bright highlights on the branches and tree trunks.

When I returned to the same location in the middle of a rainy summer, the cascading water looked like a pattern of silver lace under the canopy of green leaves. There was no distinct pattern of sunlight and shadow to define the composition, so I had to play on the even rhythm of darks and lights to define the picture.

I had to get very close to the waterfall to be able to see it through the trees, so I used my Open Box M pochade box attached to a camera tripod in order to work on top of a large rock right alongside the stream. My French easel would have been too big and precarious for the location.

I also decided to paint the scene with oils rather than alkyds because I wanted to be able to continuously blend the wet colors as my brush followed the movement of the rushing water around the dark rocks. Furthermore, I needed to be able to darken or lighten the forms to make sure the sharply contrasting values came together as a believable picture. The results are shown on the next page.

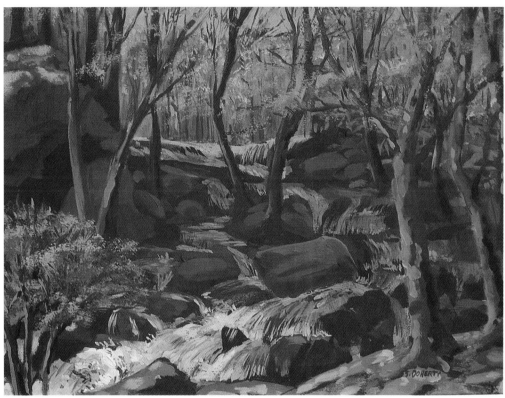

The Completed Painting: SPILL WAY IN SPRING, 1996
Oil, 9 × 12" (22.9 × 30.5 cm).

A vertical format seemed more appropriate for the view of the same spill way in the summer.

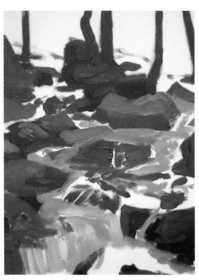

Using dark mixtures of blues, purples, and greens, I tried to capture the feeling of the water cascading down the rocks.

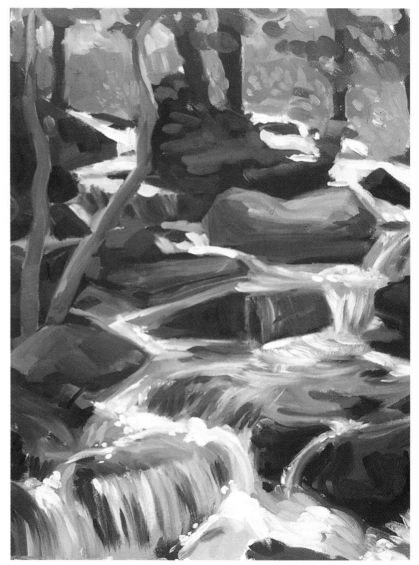

The Completed Painting: SPILL WAY IN SUMMER, 1996
Oil, 12 × 9" (30.5 × 22.9 cm).

A Multiple-Focus Approach

The waterfall paintings reproduced here and on the next page were created while I was a guest of artists Jack Beal and Sondra Freckelton at their country home in upstate New York. I've had the privilege of sitting in on the lectures both artists have given during summer workshops at the farm, and of setting my easel up along the stream that flows beside the studio building where the workshops are conducted.

Instead of the waterfall flowing through the picture as it did in the paintings shown on the previous pages, this cascade is at the vertex of curving rocks, bushes, and trees. The challenge of painting the scene became one of using the waterfall as the center of attention while building interest in other parts of the landscape. In both cases, I started painting in the morning when the light was coming from behind the waterfall, casting most of it into shadow and allowing the sunlight to bring attention to other parts of the scene.

I tried to use the lines established by the rocks, bushes, and stream to bring the viewer's attention around and through the composition rather than focusing just on the waterfall. I also made an effort to repeat colors, shapes, and patterns to unify the painting.

The early morning painting was done in alkyds, but because of the high level of humidity the paint didn't dry any faster than the oils used for the summer landscape.

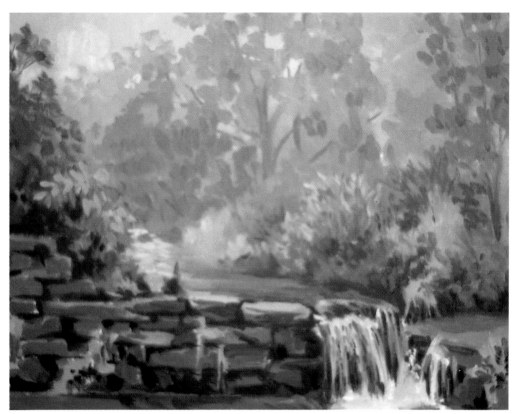

ONEONTA MORNING, 1993
Alkyd, 11 x 14" (27.9 x 35.6 cm). Private collection.

I started this painting by blocking in the forms with washes of burnt sienna and then blocked in the darks with thicker mixtures of alkyd paint.

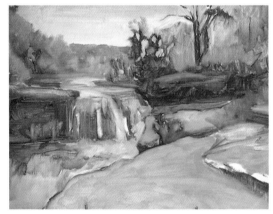

I continued with thicker mixtures of the local colors, using smaller brushes to establish details.

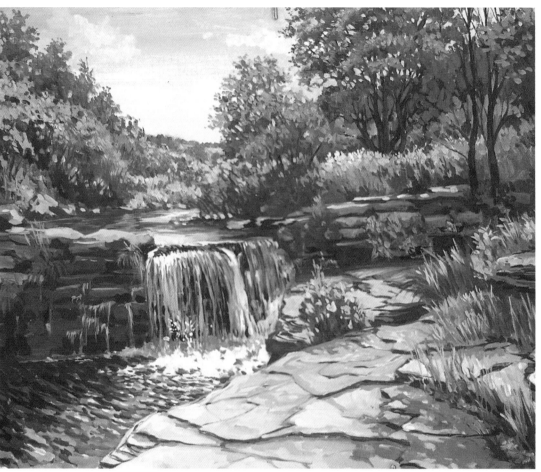

The Completed Painting: ONEONTA FALLS IN SUMMER, 1994
Alkyd and oil, 20 × 24" (50.8 × 61 cm).

Here the shoreline cuts the picture in half and offers little variety in the row of trees. Arrangements like this suggest balance, stillness, and constancy—qualities which many artists find undesirable.

The slight shift of the shoreline toward the top of the picture is enough to change the balance and, therefore, the feeling of the painting.

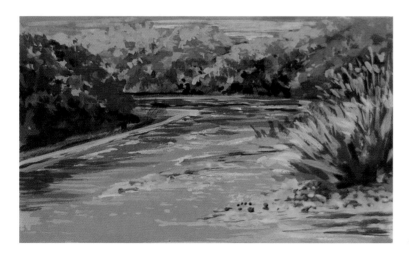

In this composition, the stream has become a diagonal force, bringing the viewer into a deeper, more engaging space, one that is likely to have more appeal to both artist and viewer.

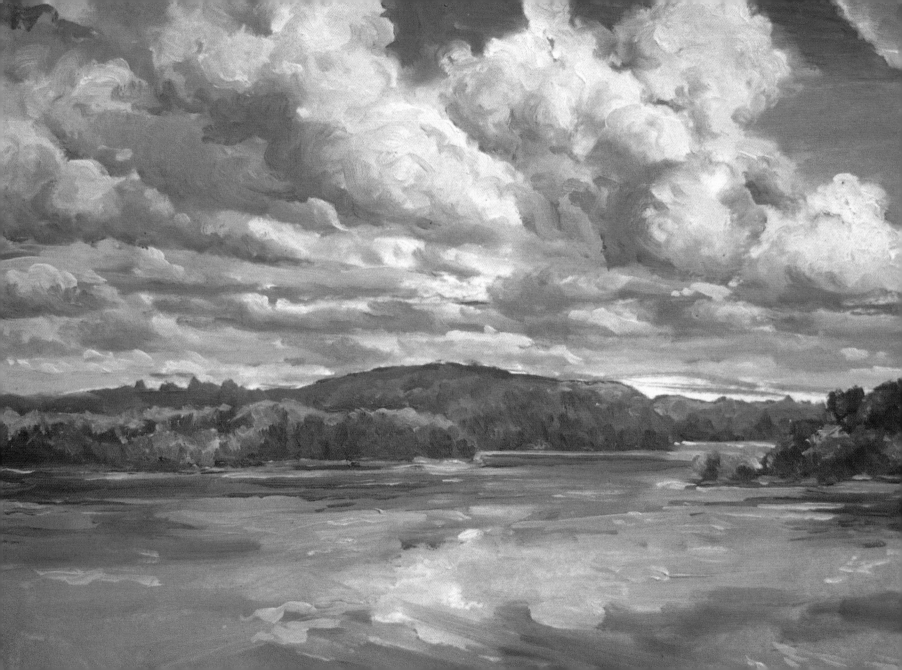

SKIES

(Above) MINNESOTA SKY NO. 1, 1992
Alkyd, 5¹/₂ × 11" (13.9 × 27.9 cm).

In preparing to paint this Minnesota sunset and the one on the next page, I laid out the complete palette and mixed large amounts of colors, including the blues that dominated the sky about a half-hour before sunset, so I would be prepared to work quickly as the bands of yellow, orange, red, and purple crossed the sky.

(Opposite) MINNESOTA SKY NO. 3, 1992
Alkyd, 11 × 14" (27.9 × 35.6 cm).

I painted this picture of clouds over a Minnesota lake after spending a considerable amount of time observing them, considering the values and colors that would be needed to paint them, and planning the steps I would follow through the process. I then painted the sky rather quickly, darkened the colors slightly to paint the sky's reflection in the lake, and then painted in the distant hills.

Some artists treat skies as backdrops to the activity within landscape paintings, laying in an even wash of blue behind the trees and buildings. Others make skies an integral part of that activity by swirling blues, white, purples, oranges, and reds through the upper parts of the canvas as Van Gogh did in *Starry Night*. In the paintings shown in this chapter, the skies are essential to the total composition.

Most artists follow what seems to be the logical procedure of working from the top to the bottom and from the background to the foreground of a picture. That means they usually paint the sky before the land. But Clyde Aspevig says he finds it makes better sense to paint the land as you see it and then paint the sky. That way, he reasons, you won't paint the land too dark in comparison to the sky.

Because it often takes several layers of light blue to effectively build up the appearance of the sky, I usually apply one thin coat of light blue to the sky area that is absorbed into the canvas or panel, then I paint the land formations, and finally I go back over the sky with a second or third layer of the blue.

Sketching Momentary Patterns

In 1996, I had a chance to see a number of the outdoor paintings the French artist Jean-Baptiste Camille Corot (1796–1875) created in Italy in the first half of the nineteenth century. In my opinion, they are among the greatest landscape paintings ever created. In carefully studying these oil-on-paper pictures, I noted that almost all of them were done late in the afternoon, when a warm light cut through the landscape at a sharp angle. That added drama, atmosphere, and dimension to the presentations.

The challenge in trying to adapt Corot's approach to landscape painting is that there is so little time available for painting as the sun quickly sets below the horizon. One of the ways of meeting that challenge is to make a pencil drawing of the scene hours before the sun sets and then apply the oil colors just as the skies put on their chromatic spectacle, as Corot seemed to do. Another would be to have a complete palette of color and some small prepared canvases ready for the frantic end-of-the-day painting. The latter approach is the one I took when painting the sun setting over a lake in Minnesota. The study reproduced on the previous page, *Minnesota Sky No. 1*, and the study reproduced here, *Minnesota Sky No. 2*, were done within minutes of each other.

MINNESOTA SKY
NO. 2, 1992
Alkyd, 5 × 11"
(12.7 × 27.9 cm).

For me, clouds are the performers who turn a blank sky into a Broadway stage. I often find myself staring out the windows of airplanes and commuter trains, trying to better understand the structure of cloud formations. I find that useful in being able to paint them because most of the time I have to rely on my memory rather than direct observation. Clouds change much too quickly to be defined in the same way that I can record the appearance of a tree, mountain, or stream.

One of the things I've learned from these observations is that the entire sky is much lighter in value than anything on the ground and, therefore, I need only subtle shifts in colors and values to accurately define the clouds. That is, the rounded white shapes on the sunlit side of the cloud are not dramatically lighter in value than the blue next to them, and the purple-gray shadow under the cloud is almost the exact same value as the blue sky adjacent to it.

I've also learned not to paint those bright rounded forms pure white because doing so creates a flat, dull cloud. I always add a touch of burnt sienna, yellow ochre, or permanent rose to the titanium or zinc white.

The painting *Minnesota Sky No. 3*, shown on the opening page of this chapter, shows how I handled a cloud-filled sky after spending a considerable amount of time studying the scene and preparing my supplies.

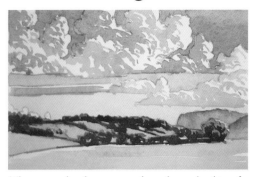

The oil illustrates how the slow-drying paint can be continuously blended to create subtle transitions and soft edges.

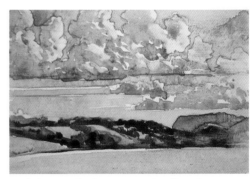

The watercolor demonstrates how the stark white of the paper (in this case a hot-pressed watercolor board) establishes the bright highlights.

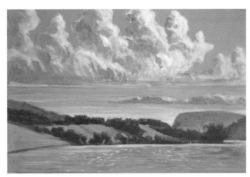

The acrylic shows the versatility of the medium in that the landscape was painted over a layer of bronze metallic paint.

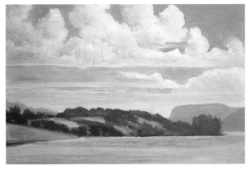

And the gouache demonstrates the effects that can be achieved by painting over a surface that has been sealed with acrylic matte medium.

Observing Dusk and Dawn

The next three chapters describe in some detail the challenges of recording light at dusk and dawn, but I want to mention here how one might paint the clouds at those magical times of day. Once again observation and analysis become important to the process because they help in conceptualizing why some clouds appear as dark purple shapes while others ripple with bands of yellow, orange, and red.

As the sun rises or sets, clouds will either be above or below the path of light rays that are shooting up from below the horizon. If the clouds are below the sun's rays because they are lower in the sky, the clouds will appear as dark, solid masses. If, on the other hand, they are above the path of the rays, they will be edged with brilliant yellows, oranges, pinks, reds, and purples. If you set your

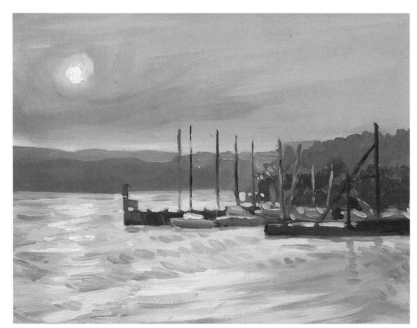

SUNSET ON THE CROTON YACHT CLUB, 1996
Oil, 11 × 14" (27.9 × 35.6 cm).

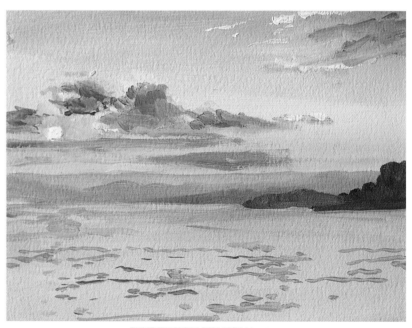

SUNSET FROM SENASQUA, 1996
Oil, 11 × 14" (27.9 × 35.6 cm).

easel up just before dusk or dawn and observe the clouds, you can almost predict the moment when this spectacle will be the most interesting and, therefore, the most painterly.

I should also mention that I often decide whether or not to paint at dawn or dusk based on the cloud patterns I see just before the forecasted time for sunrise or sunset. I wake up about ninety minutes before the sunrise and go outside to see if the morning is going to be overcast, clear, or partially cloudy. If I observe either of the first two conditions, I go back to bed because neither condition is very appealing to me. Similarly, if there aren't any clouds at the end of the day, or if those that exist are so high in altitude that they will disappear when the sun begins to set, I don't bother going out to paint.

The paintings reproduced here were done either at dawn or at dusk on small Masonite and Gessobord panels. All were completed in less than an hour, and some as quickly as fifteen minutes. Morning paintings are somewhat harder to create than night pictures because I have to set up my easel during the cold, dark hours before sunrise.

SUNRISE IN GREENSBORO, NORTH CAROLINA, 1995
Alkyd, 11 × 14" (27.9 × 35.6 cm).

LIGHT

(Above) LEOPARD APPALOOSA, by Gil Dellinger, 1996
Pastel, 30 × 42" (76.2 × 106.7 cm).
FORBES Magazine Collection.

(Opposite) CAT MOUNTAIN: FORBES TRINCHERA
RANCH (detail), by Gil Dellinger, 1996
Pastel, 20 × 60" (50.8 × 152.4 cm).
FORBES Magazine Collection.

The most direct way of painting a landscape is to use the actual local colors revealed by the light. That is, the barn is red, the grass is green, and the sky is blue. (That's more or less what I did in the first painting in the demonstration on page 70.)

The California plein air painters who were active in the first three decades of the twentieth century used a different approach to the treatment of light and color. The unifying notion is that the perception of light and color are relative. That is, the color of a barn or tree depends on what surrounds it, on the atmosphere in which it exists, and on the light which reveals it to us.

A third approach to handling the effects of light in landscape painting is exemplified in the work of James Abbott McNeill Whistler (1834–1903), who had a great deal of influence on artists working at the end of the nineteenth and beginning of the twentieth centuries. One of the hallmarks of Whistler's oil paintings is the application of paint describing a limited range of values and colors. Unlike the Impressionists, who applied thick strokes of oil colors from an extensive palette of colors, Whistler would wipe off most of the paint brushed on to the canvas, leaving subtle blends of tones and soft edges between forms. With a few layers of gray colors, he was able to suggest the light bathing a landscape or the cloth draped around a portrait subject.

Using color as it is perceived directly. I used the contrasts of warm and cool colors and the complementary relationship of red and green to establish the sense of light and space within the picture.) The green in the trees was darkened by the addition of cadmium red, and the warm yellow sunlight on the roof becomes a cool blue shadow. These are techniques one can find in landscapes painted by historic figures like Paul Cézanne (1839–1906) and Claude Monet (1840–1926).

The plein air style: In the painting shown here, done in the hazy light of southern California, shadows turn blue and purple against the golden-pink sky, and barns are perceived as cool blue and purple structures when bathed by the shadows.

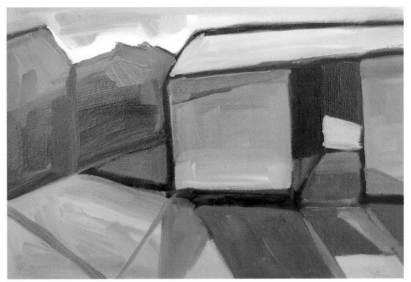

I painted this version of the barn landscape by employing Whistler's technique of using a thin application of gray color. Note how the white shapes glow next to the veils of red and green.

I gave my final version of the barn landscape a linear, graphic quality by first painting lines around the shapes and then filling in the spaces with color. You'll see that the presence of those lines gives the barn, trees, and grass a flat, abstract look. I could have pushed that style even further by using colors other than those normally associated with the elements in the landscape—say, yellow for the barn and purple for the trees. That would have taken the picture one step further into abstraction, telling the viewer that the picture was about the relationship of forms rather than the ability of those forms to create the illusion of a real landscape.

Setting Up

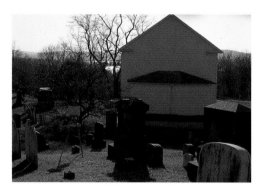

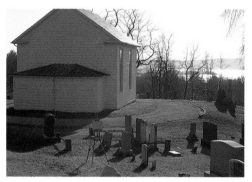

In most situations, you'll have several vantage points to choose from as you consider where to place your easel. These four views of my French easel set up at different places around the same chapel illustrate how the angle of the light completely changes the presentation of a subject. In the first photograph, the sunlit front of the building dominates the view (note how the painting surface had to be turned so the sun wouldn't shine directly on it), while in the second the sunlight is reduced to a sliver of space. The third and fourth photographs show the easel positioned behind the church so there is backlight on the subject in one view and long shadows in the other.

There is no right or wrong about how the light should reveal the landscape, but you'll undoubtedly have stronger personal responses to some situations than to others. Looking at these views of the church, for example, I'm sure there is one photograph that you feel has greater potential for a landscape painting than the others. Your main considerations should be the way the light illuminates your painting surface and palette, and how the light is likely to change during the time you are painting your picture.

Painting outdoors sometimes requires you to use the light that happens to be available for illuminating your painting surface and palette. If that light is weak, if it changes while you're painting, or if its color makes it difficult to judge the mixtures of paint on your palette, you may need to adjust the colors and values when you return to your studio.

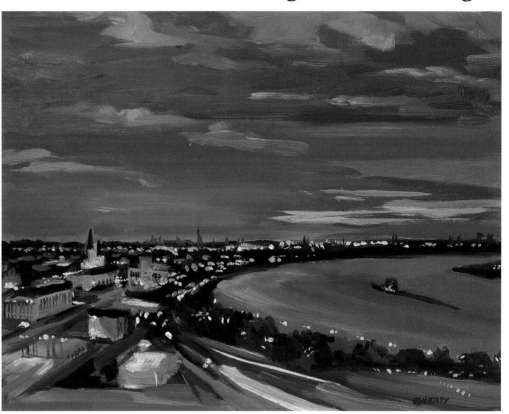

MORNING ON THE MISSISSIPPI, 1995
Alkyd, 11 × 14" (27.9 × 35.6 cm). Private collection.

DAWN IN GULFPORT, 1996
Oil, 11 × 14" (27.9 × 35.6 cm).
Courtesy Bryant Galleries, New Orleans, Louisiana.

The December morning I set off to paint this picture was rather chilly, so I stayed in my car for a while squeezing paint onto my palette. Once the color spectacle began on the horizon, I stood by my easel using the light from a security spotlight on a nearby building to illuminate the painting surface. That was obviously an inadequate light source, and I had to adjust the colors and intensify the dark tree shapes after the sun had completely risen.

Artist Alan Flattmann, who has been painting in the French Quarter section of New Orleans for more than thirty years, once gave me a list of little-known places that afford great views of the city. One is a parking garage behind Canal Place, a high-rise shopping mall and office building. It offers a fine view, protection from the elements, and privacy. I did this painting from one of the upper floors of the garage as the sun was rising. I had a great view of the sunrise, but the light inside the space was a combination of fluorescent and tungsten. Once again, I had to adjust the values and colors after the sunlight made it easier to judge what I had done.

Enhancing Midday Light

SENASQUA WILLOWS, 1993
Alkyd, 11 × 14" (27.9 × 35.6 cm). Private collection.

Because the even light at midday didn't produce a strong pattern of light and shadow, I made the lace pattern of the willow branches and leaves the real focus of this painting.

Many landscape painters find the middle of the day to be the worst time for painting because there aren't enough shadows to give dimension, texture, and contrast to a scene. That's especially true if you're trying to paint mountains in the Southwestern states, where the even midday sun washes out the appearance of rocks and ledges.

One solution is to paint subjects that don't need an angled light to make their surfaces interesting. In the case of the painting shown here, for example, I focused on the lace pattern of large willow trees along the banks of the Hudson River. The positive shape of the trees against the negative space of the background river was enough to make the scene paintable. In other situations, I've exaggerated what few shadows existed so I could get the contrast and dimension I needed.

Capturing Fading Light

I find oil paints particularly well suited to recording sunsets in a matter of minutes because I can continually blend colors together, soften edges with the wisp of a clean brush, or wipe out sections and repaint them. The two paintings reproduced here were done in a half-hour as the sun set over the Mississippi River and the Gulf of Mexico, respectively. My intention was to be as accurate as possible in painting the colors and shapes I observed before the entire scene changed. The painting of the Mississippi was done on a small Solid Ground panel while the other picture was painted on a sheet of Gessobord.

I've mentioned on many occasions that I usually thin my oil and alkyd paints with mineral spirits, but when painting these two pictures I worked with a painting medium made from linseed oil, turpentine, and damar varnish so the paint would flow more smoothly off my brush. I find that when I am constantly going back and forth over a painted area, the presence of mineral spirits will cause one stroke of paint to lift off what's underneath it, while using a painting medium allows the layers of colors to blend into the subtle transitions of a sunset.

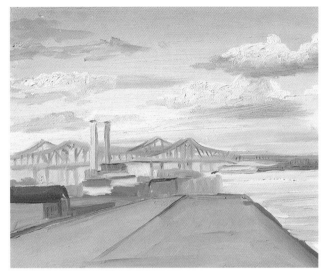

THE MISSISSIPPI FROM THE JACKSON STREET BRIDGE, 1996
Oil, 8 × 10" (20.3 × 25.4 cm).
Courtesy Bryant Galleries,
New Orleans, Louisiana.

I used a handmade wooden panel sealed with Galkyd medium for this small painting of the Mississippi River. It was done from a bridge leading to the ferry which crosses the river at the foot of Jackson Street in New Orleans.

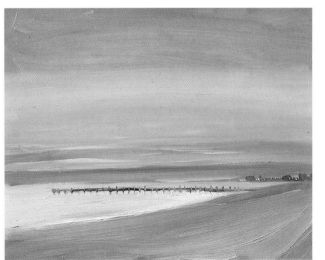

GULF OF MEXICO AT BILOXI, 1996
Oil, 11 × 14" (27.9 × 35.6 cm).
Courtesy Bryant Galleries,
New Orleans, Louisiana.

I chose to paint this scene with oils so the surface would remain wet long enough for me to blend colors right on the painting. I used a large, flat-bristle brush that put a lot of paint on the panel with each stroke.

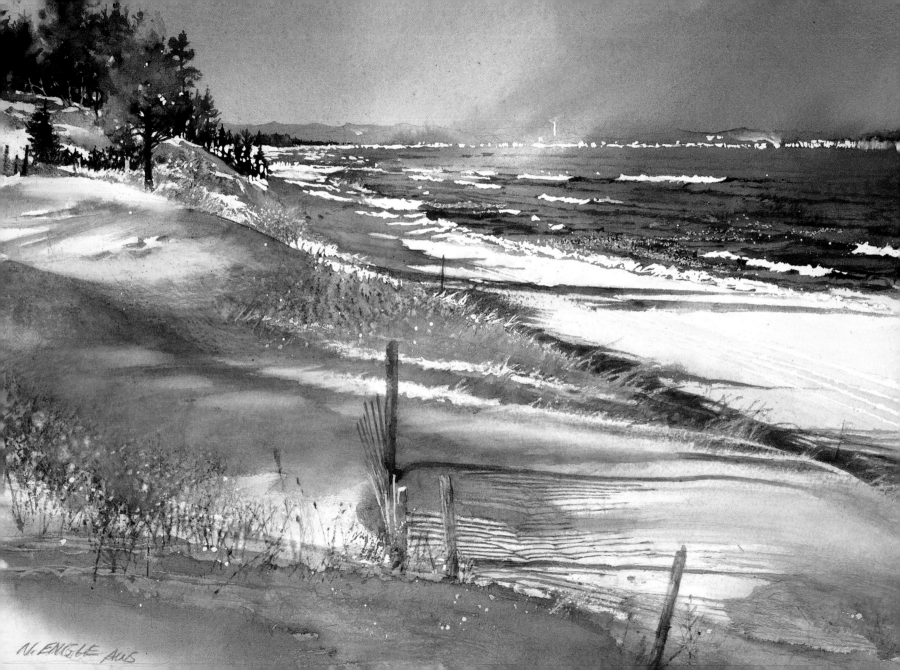

N. ENGLE AWS

SHADOWS

(Above) ANN RICE'S HOUSE IN THE GARDEN DISTRICT, 1994
Alkyd, 11 × 14" (27.9 × 35.6 cm).

I painted this picture late in the afternoon on an overcast day when there would be enough light to reveal the entire scene, yet enough darkness to make the porch lamps and interior lights become noticeable. I added ivory black to my palette to mix with the greens and browns so they would have the dark intensity I needed. Because I wanted the shadows in this picture to be duller and flatter than those in the street scene on the next page, I used less blue and purple.

(Opposite) EDGE OF WINTER: LAKE SUPERIOR, by Nita Engle, 1988
Watercolor, 19¹/₂ × 29" (50 × 73.7 cm).
Courtesy Mill Pond Press, Venice, Florida.

I've often heard landscape painters say they are more concerned with the pattern of light and shadow than the identifying elements of a scene. That is, as they look around for something to paint, they want to find an interesting pattern of light and shadow that gives dimension, drama, color, and form to the landscape. Without those qualities, the tree, river, field, or ocean is likely to be a flat, boring subject.

Where there is light, there is shadow. But artists don't necessarily paint transparent purple and blue shadows the same way that they paint golden strokes of sunlight. Shadows are usually created with thin mixtures of several colors that complement those in the light, while sunlight is commonly represented with thick applications of tinted colors.

Watercolorists, however, paint shadows, not sunlight. The bright shapes within their pictures are the patches of unpainted white paper surrounded by shadows. Nita Engle offers an excellent demonstration of that practice with her painting of the shoreline of Lake Superior in winter, shown on the opposite page. Note how she has used soft wet-in-wet shadows in the foreground, crisp blues in the middle of the picture, and a deep gray-blue in the water to set off the white of the snow along the shore and the waves rolling in from the lake. Even the sky is a rather dark blue-gray above the sparkle of white on the distant shore.

Using Shadows to Mark Planes

In this painting of the street in front of Ann Rice's house in the Garden District in New Orleans, the shadows dominate the scene, and the purples and blues that create those shadows help to establish the planes and space within the composition. The architecture of the buildings, the span of the streets and sidewalks, and the grid pattern of the fence are defined by the shadows, and the pattern of dark and light leaves in the massive live oak trees gives a sense of dimension and scale to those arching forms.

After lightly sketching in the total composition, I blocked in the dark greens in the oak trees.

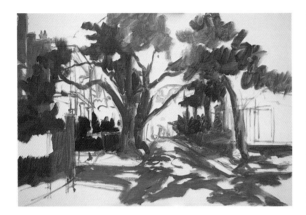

Next I painted the first layers of purple and blue shadows across the streets and sidewalks.

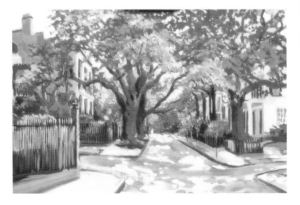

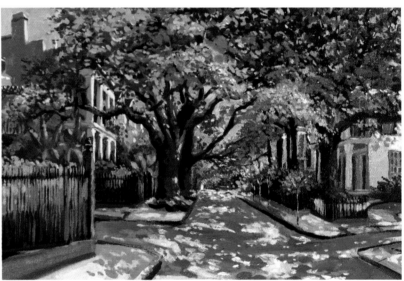

The Completed Painting: ANN RICE'S LIVE OAKS, 1995
Alkyd and oil, 20 × 30" (50.8 × 76.2 cm). Courtesy Bryant Galleries, Jackson, Mississippi.

Using Shadow to Brighten Sunlight

I'm always reminding myself that the way to create bright shapes in a painting is to paint the shadows surrounding them. That may seem like an obvious statement, but I think most of us have to be reminded to think about contrasts in values. We get so involved in mixing the right colors on our palettes that we forget that the perception of color is completely relative. A very gray yellow may appear brighter than a crisp lemon yellow if the values surrounding it are much darker. The two paintings here illustrate how this principle can be applied to light and shadow.

Look at the painting of a white dogwood in front of a historic home in Natchez, Mississippi. The reason that tree is so bright is because it is surrounded by shadows on the porch and in the trees. I had to keep the sunlit highlights on the columns to a minimum so the house would remain in the background and would not deflect attention from the center of interest.

In contrast, the intense dark shape of the tree in the other painting becomes the foreground of the space while the lighter values establish the background. But even in this painting it is the distinction between the shadow and sunlight that is most important.

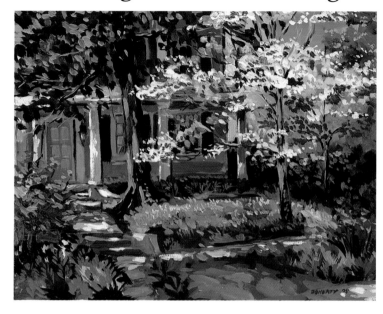

RAVENNA MANSION, NATCHEZ, MISSISSIPPI, 1995
Alkyd, 11 × 14"
(27.9 × 35.6 cm).
Private collection.

The brilliance of the white dogwood stands out against the shadowed house and lawn.

SHADOWS IN CITY PARK, 1996
Alkyd and oil, 11 × 14"
(27.9 × 35.6 cm).

The values of the dark tree and the light background are exaggerated through contrast.

Demonstration: SHADOWS AND SNOW—FOUR APPROACHES

Artists have very firm ideas about the colors, textures, and patterns that should be used to record the pattern of shadow on a landscape. The paintings shown here, in which the shadows dominate the composition, show just four of the myriad options. Variation is achieved both by changes in the palette of colors used and in the way they are applied.

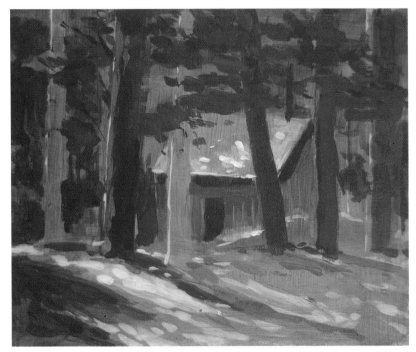

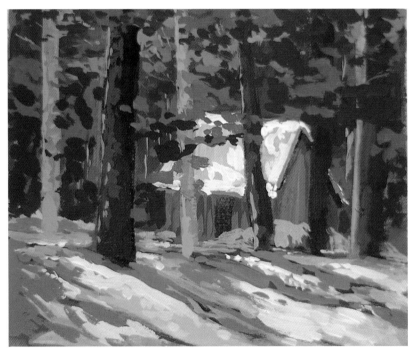

I used glazes of black paint over purple and blue to create a dark, muted picture. Then I painted the sunlit shapes with thin mixtures of orange and yellow, followed by dabs of opaque titanium white. The sharp contrast between light and dark draws the viewer's attention immediately to the spots of sunlight.

Here I used an Impressionist technique of building up strokes of color over a base of burnt sienna. I avoided using black (a color the French Impressionists believed was not found in nature) and made the darks from combinations of purple, burnt umber, and French ultramarine blue.

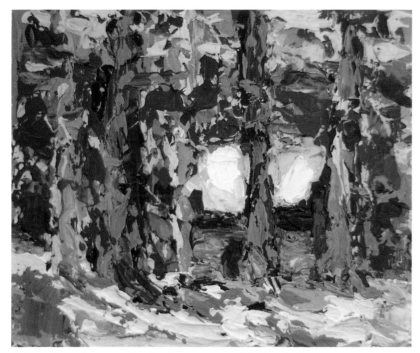

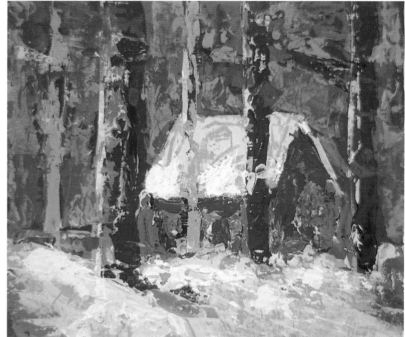

I chose almost the same colors for this painting as I did for the Impressionist variation, but in this case I applied acrylic paint liberally with a flexible palette knife. I made the paint as thick as cake icing and literally slathered it on the canvas, creating the rough texture of the picture.

For this version of the cabin and trees, I applied a variation of a technique used by artists associated with the Cape Cod School of Art in Massachusetts. These artists exaggerate the extremes of warm and cool colors, first underpainting the elements of their landscapes or still lifes with bright yellows, reds, and oranges where they plan to build the warm tones and with blues, purples, and lavenders where they see the cool colors. Underpainting like the one in this picture, which established a sense of depth and dimension, can be used to advantage in any type of landscape.

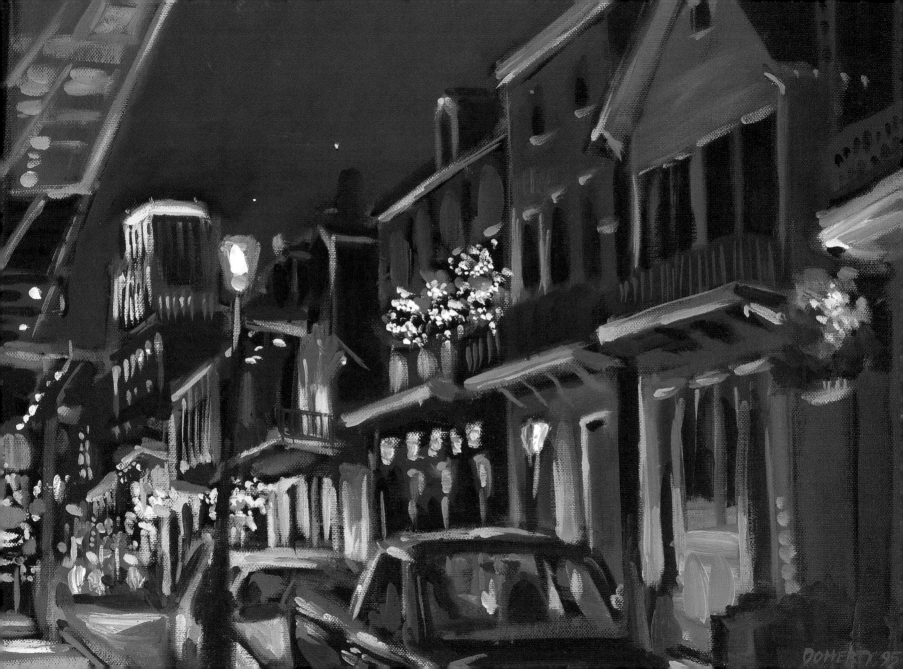

CHAPTER 10

CAPTURING A TIME OF DAY

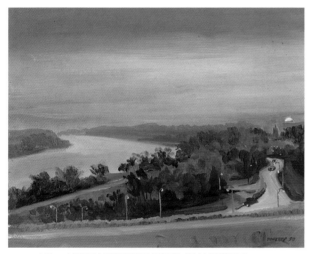

(Above) THE MISSISSIPPI RIVER AT NATCHEZ, 1995
Alkyd, 11 × 14" (27.9 × 35.6 cm).

(Opposite) NEW ORLEANS STREET SCENE: NOCTURNE I, 1995
Alkyd, 16 × 20" (40.6 × 50.8 cm). Private collection.

I made a quick drawing on the black canvas with a blue made from titanium white and phthalo blue so I could fix the perspective of the buildings before the sun set. Once night had fallen, I painted the magical display of colored lights.

Very few locations are interesting at all times of the day. Most come alive when the light is at a certain angle, when the streets are bustling, or when the seasonal markings create excitement. It is helpful, therefore, to keep track of where to go for the best morning, afternoon, and evening pictures. I make mental notations about whether the garden is more appealing in shadow or full sunlight; if the angular shadows on a building become more dramatic at certain hours; and at what time the atmosphere clears up enough to expose the greatest distances.

Setting Up Early

One summer in New Orleans, I decided to try going out about an hour and a half before the sun rose in the morning to paint the dark buildings below the pinks, reds, and purples of the morning sky. It took a bit of experience to know what locations would prove to be the most interesting once the sun rose, and I had to learn to anticipate what would happen to the appearance of the buildings and wet streets once the colors emerged in the sky. Furthermore, I had to find locations where there would be enough illumination from street lights, retail shops, or spotlights to reveal my palette and painting surface while I prepared to paint the emerging light and during the early stages of that painting process.

I became familiar enough with the process to be able to identify good painting locations a day or two before setting up my easel at 5:00 a.m. There wasn't much point in doing any preliminary painting because the lights of dawn presented such a distorted view of the buildings, trees, streets, and cars.

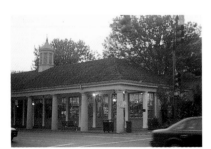

Photographs of the market taken after the sun had risen and the painting had been completed.

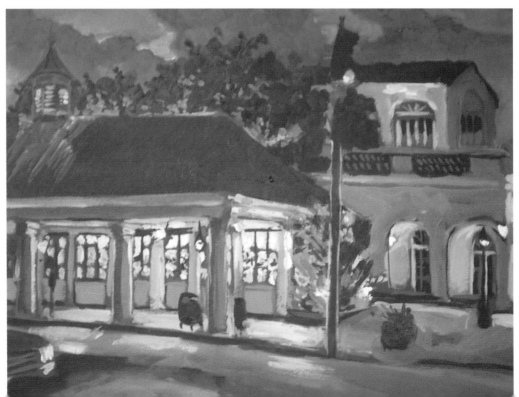

MORNING AT THE MARKET,
1994
Alkyd, 11 × 14"
(27.9 × 35.6 cm).
Private collection.

If you get involved in a complicated picture or start on one that depends on a fleeting pattern of light and shadow, you may find that the only way to capture what you want is to return to the location at the same time of day (assuming the conditions are similar) to collect all the information you'll need to finish the painting. Otherwise you'll have to rely on your memory, photographs, or small sketches to help you complete the picture back in your studio.

One early morning I noticed that a strange combination of colored lights made the historic Beauregard House in New Orleans particularly captivating at that hour. I began the painting before the sun rose, using the light of a corner street lamp to illuminate my palette and painting surface. After about an hour, the morning sunlight totally changed the scene, and I had to return to the scene the next morning to complete the picture.

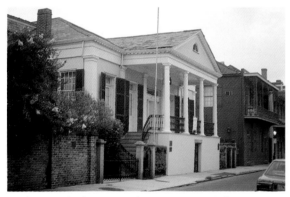

A photograph of Beauregard House in New Orleans.

**BEAUREGARD HOUSE
AT DAWN, 1994**
Alkyd, 11 × 14" (27.9 × 35.6 cm).
Private collection.

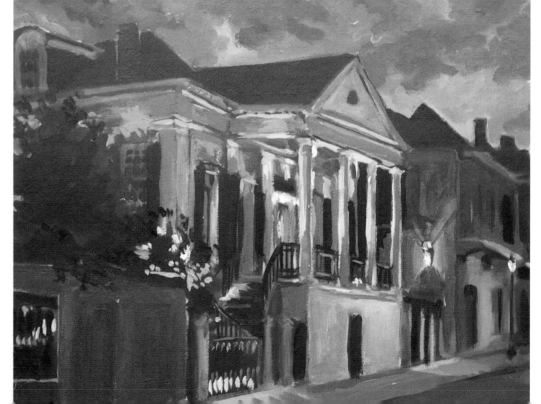

Painting at Night

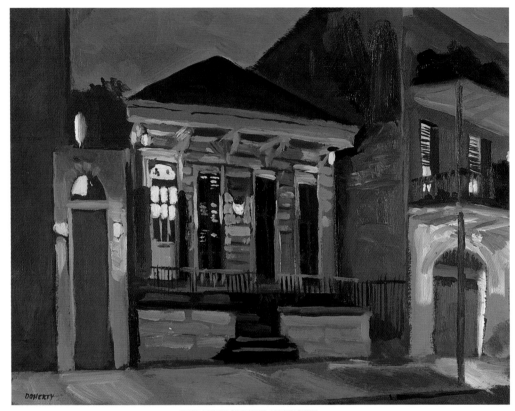

DUMAINE STREET AT NIGHT, 1994
Oil, 11 x 14" (27.9 x 35.6 cm). Courtesy Bryant Galleries.

It was difficult to paint outside one evening, so I set my easel just inside the screen door of the house where I was staying and painted the historic home directly across the street. Phthalo blue and phthalo green proved to be the perfect pigments for duplicating the Paris green color of the building.

One evening after dinner while I was walking back to my rented room in the French Quarter in New Orleans, I noticed how places that were totally uneventful during the day became magical when illuminated by blue, green, red, yellow, and white lights. I decided to figure out a way of painting along Bourbon, Royal, and Dumaine streets where the night was alive with strange lights and jubilant people.

Night scenes don't change as much from one day to the next as daylight landscapes, so it's easier to predict what will happen and to return to a location if more than one painting session is required. About the only aspect of the scene that might be different from one evening to the next is the amount of light in the sky. If there is a thick, low cloud cover, or if there is a full moon, the sky will be a gray, purple, or dark blue depending on the amount of artificial light being reflected off the clouds. On a clear night when there isn't much of a moon, the sky is likely to be pitch black.

USING EXISTING LIGHT

When I first attempted nocturnal paintings, I bought several battery-powered lanterns, large flashlights, and a snake-coiled flashlight so I could illuminate my canvas and palette well enough to accurately judge the colors. I even tried a flashlight that could be worn around my head like a coal miner's hat. I tried wrapping the lights around lamp poles, fire hydrants, and fences and occasionally carried my paintings inside bars to be sure of what colors I was applying to the picture. None of these techniques was entirely

satisfactory, and I found that the best arrangement was to stand under a street lamp and use the flashlights for an occasional check on the developing picture.

COMPLETING NIGHT SCENES IN ONE SESSION

The process of painting nocturnes went more quickly when I started painting on black canvases rather than gray or white ones, so I prepared several different-sized canvases by coating them with two layers of lamp black alkyd paint. Knowing that the larger the canvas the more time it takes to paint a picture, I selected the size canvas that I felt I had the time and energy to complete in an evening. Almost all of my nocturnal paintings have been done with alkyd paints because I've wanted to build up as many layers of paint as I could during the time on location. Furthermore, knowing that I had to carry paintings back home on an airplane, I wanted to be sure they would be dry by the time I packed my bags.

Whenever possible, I set my easel up a hour before the sun sets and sketch in all the buildings and vegetation in a scene while there is enough sunlight for me to accurately view the scene and my canvas. Next I lay out the complete palette of colors I expect to use and wait for the sun to set.

A FINAL NOTE ON NOCTURNES: KEEPING THINGS LOOSE

While it is possible to render very detailed nocturnal paintings, my sense is that the subject lends itself to loose brushstrokes of paint that are consistent with the uncertain, mysterious quality of night scenes. While I frequently make accurate drawings of the buildings in a street scene just before dusk, I try not to be too precise in establishing the planes of space, the edges between shapes, and the complete identification of objects within the scene. I also find myself adding garish pinks, purples, reds, and oranges to my palette because those often match the strange reflected lights on these indefinite planes of space.

BOURBON STREET AT NIGHT, 1995
Alkyd, 18 × 24" (45.7 × 61 cm).
Private collection.

It occurred to me that it would be much easier to paint nocturnal scenes on black surfaces rather than gray or white, so I coated this canvas with two layers of Mars black alkyd paint before heading out in the evening.

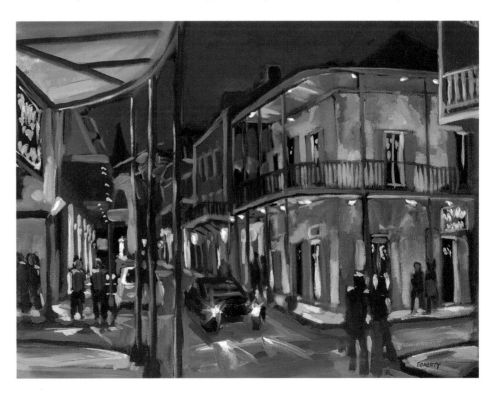

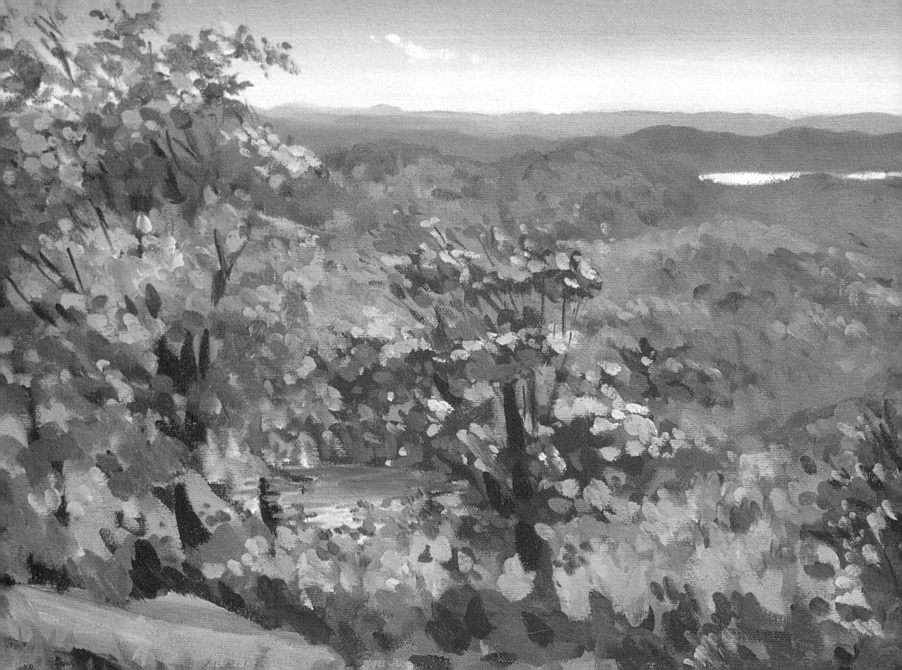

PAINTING SEASONS

(Above) BALOU HILL ROAD, WINTER, 1995
Alkyd, 11 × 14" (27.9 × 35.6 cm).

*This road in winter is one of a series of seasonal paintings I did
of this scene (summer and autumn are reproduced in Chapter 13,
pages 109 and 110). Note that the white road in my autumn
version became almost black, and the dark foreground of my
summer picture became a light value.*

(Opposite) DETAIL, AUTUMN FROM TURKEY MOUNTAIN, 1995
Alkyd, 12 × 24" (30.5 × 61 cm).

*This painting was done in the autumn on stretched canvas with
a palette of alkyd paints.*

Teachers often recommend that their students paint the same still-life objects,
people, or plots of land over and over again so they get to know their subjects
well, learn to focus on an interpretation of those subjects, and pay less attention
to capturing the obvious appearance and more attention to their interpretation.
One way to do that is to choose a location and paint the same scene during
each of the four seasons.

The View from Turkey Mountain: Fall to Summer

I decided to set up my easel up at a specific location at different times of the year so that I could explore ways of composing the most interesting views available, choosing the most appropriate painting materials for the assignment, and adjusting my palette to get the most accurate record of the scene at each time. The view I chose was the view from Turkey Mountain in Yorktown Heights, New York. To make the project even more challenging, I chose a location at the top of a hiking trail that would give me an expansive view. I hauled my easel, bags of supplies, canvases, and panels up and down the trail five times in one year and spent anywhere from two to four hours painting the view. The wind, chilly breezes, poison ivy, bugs, and uneven terrain worked against me, but I became so absorbed in the process of painting the panorama that

I didn't really mind these inconveniences. I just worked on smaller panels when I knew it would be difficult to stay focused for more than a couple of hours.

Each of the finished paintings of the view from Turkey Mountain shown in this section progressed from the distant to the near forms, starting with the sky and the mountains and moving forward in space to the rocks and bushes beneath my feet. The prestretched, preprimed canvas was toned with a thin mixture of light blue-gray to help push the distant mountains deep into the space. For all of them, I used only three or four brushes, starting with a No. 10 bristle brush, moving to a Winsor & Newton Monarch No. 8 flat and No. 8 filbert, and finalizing details with Cheap Joe's No. 6 and No. 8 Charles Sovek sables (flat and round).

Without bothering to sketch in the composition, I started painting the sky with a mixture of titanium white and cobalt blue, then gradually added French ultramarine blue and touches of burnt sienna to establish the darker, bluer shapes coming forward in space.

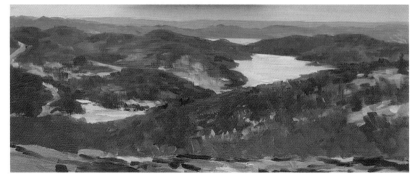

The winter view before adding the foreground trees and bushes seen in the finished painting.

Using Fall's High-Key Colors

The challenge with autumn paintings is to keep the colors from appearing garish and unnatural. Sure, you see bright yellows, ochres, reds, oranges, and greens when you look at a hillside of fall trees, but if you use tube colors to paint those deciduous trees you'll wind up with a picture no one believes. The solution is to apply an underpainting of burnt sienna; dull all the colors with blue, white, or black before you apply them to the canvas; or depend on earth colors that tend toward red, yellow, or green. If you are interested in the last of those three approaches, you'll want to buy some of the special oil colors available from each of the major paint manufacturers. Among my favorites are Holbein's brown pink, Archival's gold ochre, and Winsor & Newton's terra rosa.

Enriching Winter's Grays

This winter scene was painted on a sheet of gessoed luan plywood (very thin, flexible plywood) using essentially the same palette of alkyd colors as I had used for the fall painting. Even though the day was warm for December, it was still too cold and windy for an extended painting session. I wore felt garden gloves with the fingers cut off and an old hooded sweatshirt that I didn't mind ruining with alkyd paint.

I relied heavily on cool purples and blues to capture the feeling of stark coldness in the landscape. Most of the background and middle ground were painted on location, but I was starting to shiver by the time I got to painting details in the foreground, so I left them unfinished until I got back home.

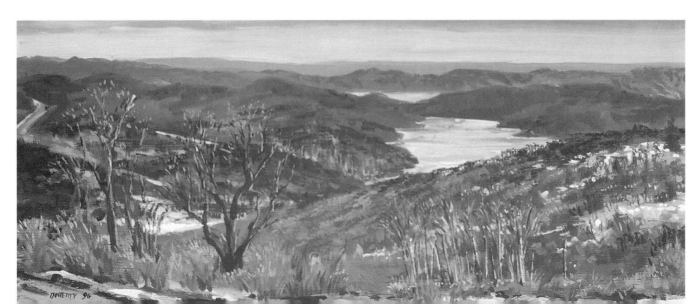

The Completed Painting:
WINTER
FROM TURKEY
MOUNTAIN, 1995
Alkyd, 8 × 18"
(20.3 × 45.7 cm).

CAPTURING SPRING'S CHANGING LIGHT

The most difficult aspect of painting in the spring is that the light changes rapidly as the racing clouds shift the pattern of shadows. At one minute the foreground is a dark form against a light middle ground, and the next moment that relationship has been completely reversed. All one can do is commit to a set of relationships that existed at one moment, remember it as best one can, and continue painting no matter what happens to the actual scene. Of course, oil paints do make it easy to revise a plan if something spectacular happens, as was the case in the upper right-hand corner of my spring painting of Turkey Mountain. The sunlight bathing the distant hills created a wonderful mist of forms that made it worth changing my original plan.

SPRING FROM TURKEY MOUNTAIN, 1996
Alkyd, 12 × 24" (30.5 × 61 cm).

The spring picture was done on plywood covered with preprimed linen canvas. The cloud pattern changed more radically while I was painting this picture than it did while I was working on the others, so in some sections I had to remember the value and color patterns that existed when I began in order to achieve a believable consistency when I finished. In particular, the distant mountains in the upper left-hand section appeared and disappeared as the shafts of sunlight burst through the clouds. I locked in one view and tried to keep the rest of the horizontal composition set to the same time and pattern.

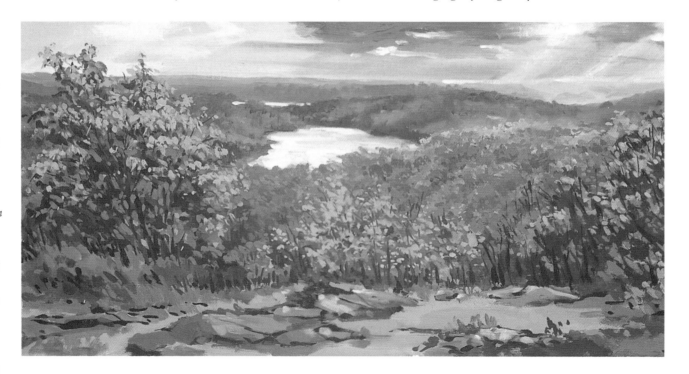

Painting Summer's Haze

The two summer paintings were done on commercially made panels—one on Gessobord and the other on a plastic Solid Ground panel. I used oils in both cases so I could blend the colors for an extended period of time and establish the hazy, overcast atmosphere. The other paintings were done with alkyds because I wanted the layers of paint to dry quickly, allowing me to build from broad washes to tight details.

I used the same palette of color, with the addition of Rembrandt cobalt violet, Sennelier peach black, and Sennelier neutral tint. Following advice I have been given by museum conservators, I used only mineral spirits to thin my oil and alkyd paints and to clean the brushes when I was finished. They advised me that turpentine is not necessary for thinning those paints and, since it is more expensive and irritating than mineral spirits, it's not worth buying. Toward the end of the painting process, I often mixed the paints with Liquin or Galkyd alkyd-based media so I could get thin, fast-drying applications of color.

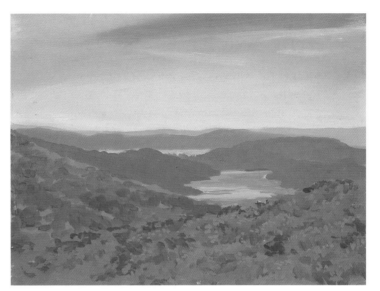

SUMMER FROM TURKEY MOUNTAIN NO. 1, 1996
Oil, 12 × 16"
(30.5 × 40.6 cm).

The most interesting aspect of the view from Turkey Mountain on hot summer days was the sultry, humid, overcast atmosphere that bathed the landscape. To record that, I chose a more traditional rectangular format rather than the long horizontal shapes of the first three seasonal paintings. I also switched from alkyd to oil paint so I would be able to work into a wet surface for two or three hours. I added cobalt violet to my palette so I could mix it with the dark tones to keep them cool.

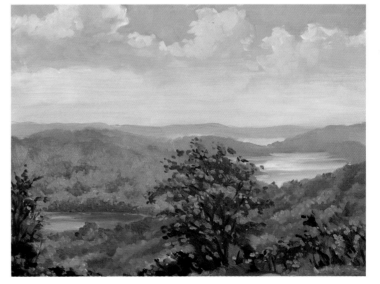

SUMMER FROM TURKEY MOUNTAIN NO. 2, 1996
Oil, 9 × 12"
(22.9 × 30.5 cm).

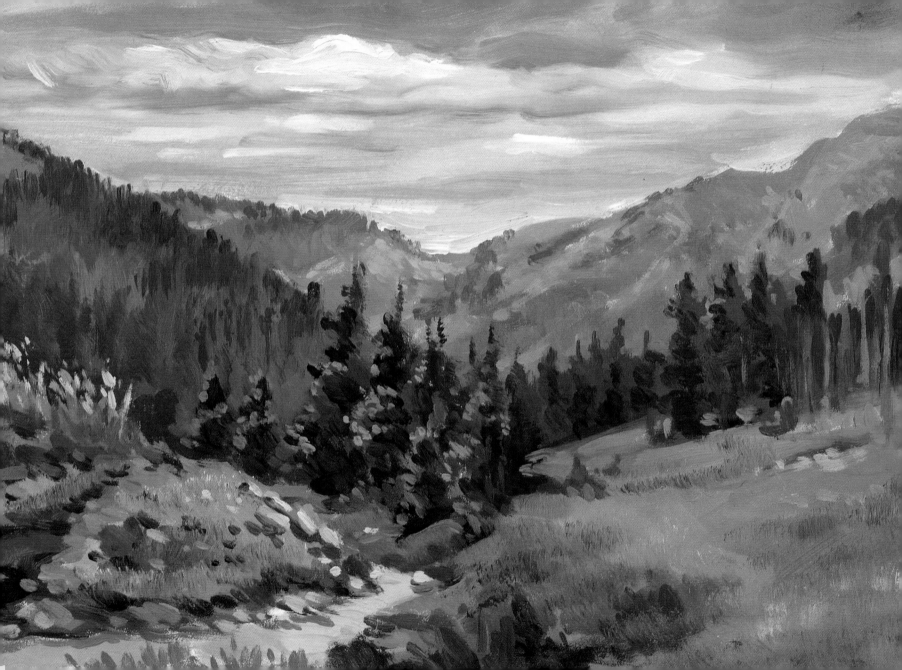

SCALE AND FOCUS

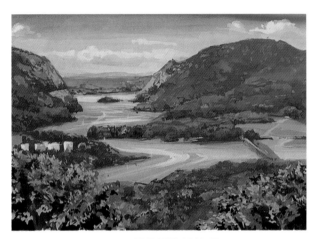

(Above) THE HUDSON AT
WEST POINT NO. 1, 1991
Gouache, 10 × 14" (25.4 × 35.6 cm).
Collection of the artist.

(Opposite) FORBES TRINCHERA
RANCH NO. 1, 1996
Alkyd, 9 × 12" (29.9 × 30.5 cm).
Collection of the artist.

The amount of real estate you attempt to present within the borders of a painting will affect the manner in which it will be created, the amount of detailing required, and the compositional devices available to you. If you stand on top of a mountain next to a wide, narrow canvas, you'll have to be content with broad horizontal bands or rapidly changing colors and values. If, on the other hand, you concentrate on a small flower garden planted between a sidewalk and a stone wall, your focus will be on the details of individual plants, rocks, and slabs of concrete.

There are, of course, many occasions when you will be interested in presenting both a wide expanse of space and the smaller objects in front of it. In those cases you'll need to establish a dual focus to your painting so the background is as important as the foreground. To accomplish that, however, you will need to create compositional devices that link one area of interest with the other, and you'll have to make sure the brushstrokes are consistent throughout the painting.

Capturing Broad Vistas

I first sketched the scene with thin paint on a canvas toned with light blue, then, using mixtures of titanium white, cobalt blue, and ultramarine blue, painted the sky.

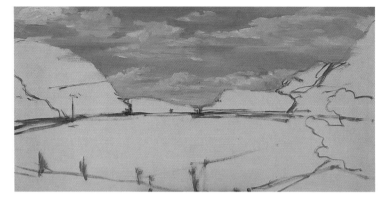

Working while the paint was wet, I blocked in the mountains and blended the colors to get the sense of them being in the distance.

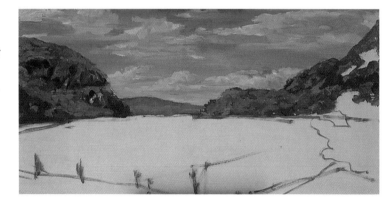

Moving down the canvas, I painted in the water and foreground beach.

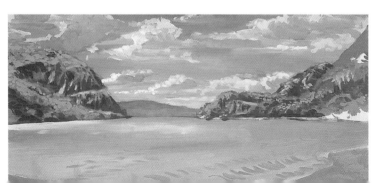

If you are interested in the dramatic lighting effects across sky, water, and land—as I obviously am— then you'll want to paint panoramic views from high vantage points. When you are pulling together an expansive scene on one canvas, the initial drawing of the landscape on the canvas is particularly important because it establishes the scale necessary for including all the important elements of the scene. In some cases, sections of land must be shortened and distances reduced in order to create a balanced and convincing picture.

Because the scenes at Cold Spring and at Boscobel were both dominated by sky and water, I painted them on canvases toned with light blue alkyd paint. Ross Merrill, a painter and the chief of the Conservation Department at the National Gallery of Art in Washington, D.C., uses a slightly different approach when painting panoramic views of the Potomac River. He tones the bottom half of his canvases with raw sienna and the upper half with light blue, which results in a warm color underneath the brushstrokes that describe the river and a cool tone under the sky. Merrill tells me that this was a common technique in the nineteenth century.

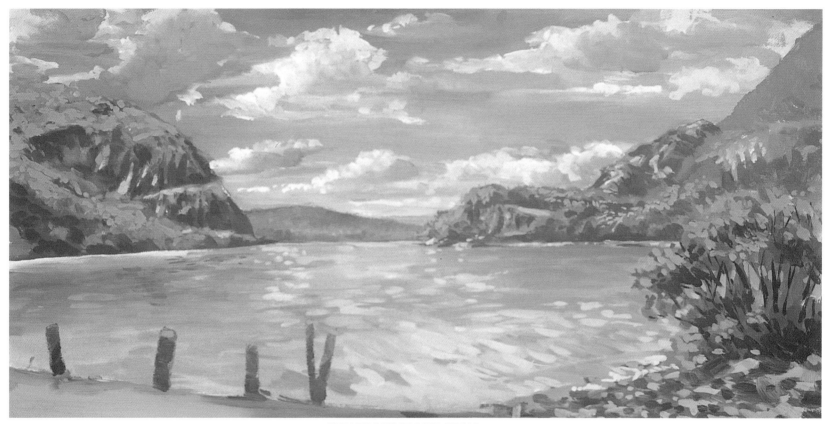

THE HUDSON AT COLD SPRING, 1996
Alkyd, 12 × 24" (30.5 cm × 61 cm). Collection of the artist.

Demonstration: HUDSON RIVER PANORAMA

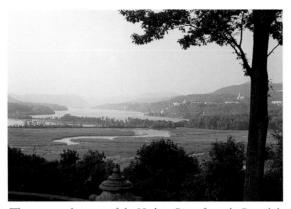

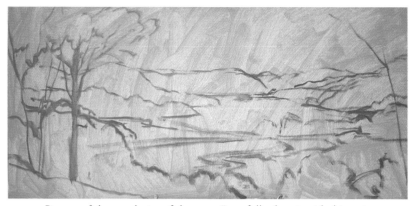

This spectacular view of the Hudson River from the Boscobel mansion is available for artists to paint only on the second Tuesday of each month. Fortunately for me, the weather on September 9, 1996, was perfect.

STEP 1. *Because of the complexity of the scene, I carefully drew it with thin paint on a canvas toned with light blue.*

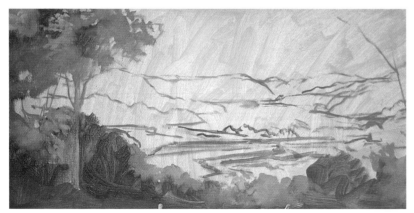

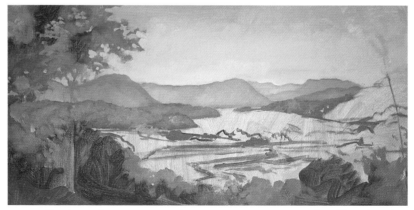

STEP 2. *Normally I would paint the distant forms first, but in this case I felt the need to establish the dark forms on the left side of the landscape so I could use them as a gauge for the rest of the value composition.*

STEP 3. *The distant forms were painted in one continuous session so I could work with the same paints on my palette and blend one shape into another on the canvas.*

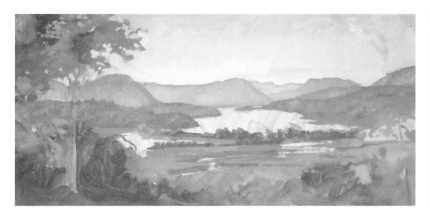

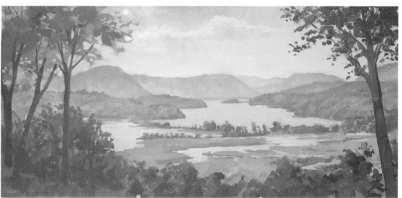

STEP 4. *Then I painted the swamp and the trees on the right side of the canvas.*

STEP 5. *I spent quite a lot of time painting the branches and leaves because I wanted them to have more detail than the rest of the picture.*

THE HUDSON FROM
BOSCOBEL, 1996
Alkyd and oil, 12 × 24"
(30.5 cm × 61 cm).
Collection Debbie Wieggel.

Focusing on Intimate Spaces

Intimate landscapes are more appropriate backgrounds for people, sculptures, garden furniture, and flowers, so if your primary motivation is to paint that kind of specific subject matter, you'll be better off confining the landscape to a shallow, well-defined space.

Virginia artist Richard Crozier recently exhibited a collection of paintings of his garden, and I asked him for permission to reproduce two of them here because I felt they offered a helpful demonstration of how one might paint intimate landscape spaces.

You'll note that the space in both of these pictures is quite shallow, with the dense foliage confining our attention to a few plants in the foreground. Strong shadows around the large clay pots and urn give a dimension to those forms and help to break up the pattern of green leaves. While the brushstrokes are broad and general, Crozier still manages to capture the unique color and shape of each plant. The raw sienna tone of the canvases unifies the composition and establishes a warm tone to the colors.

ITALIAN URN AND WILD PEONIES,
by Richard Crozier, 1995
Oil, 24 × 14" (61 × 35.6 cm).
Courtesy Tatistcheff Gallery,
New York, New York.

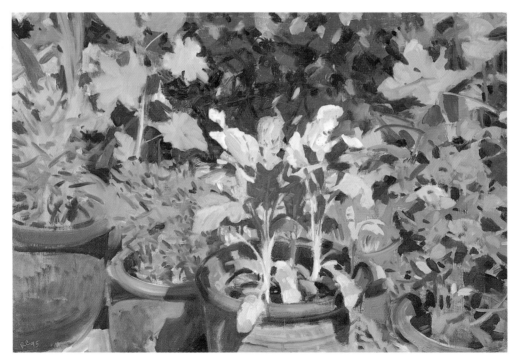

PETUNIAS, KALE,
TARRAGON, AND
PLUME POPPIES,
by Richard
Crozier, 1995
Oil, 18 × 24"
(45.7 × 61 cm).
Courtesy Tatistcheff
Gallery, New York,
New York.

Putting Flowers into a Space: A Dual-Focus Approach

As a consequence of having judged a great many art exhibitions, I've seen thousands of paintings based on close-up views of flowers, most of which were derived from photographs taken by the artists. While many of these were quite spectacular and received prizes from me, they all suffered from using an overworked format for floral painting. I would recommend that if you are so enthralled with flowers that you must paint them, try to put the blossoms into a particular space—a garden, park, patio, or urn that gives the viewer something else to consider and enjoy. In painting the hollyhocks shown in this photograph, I hoped that their placement alongside a barn wall would have something to say about their architectural stature, their hardy temperament, and their summertime appearance. I tried to make the flowers the center of attention, but within a deep, atmospheric space.

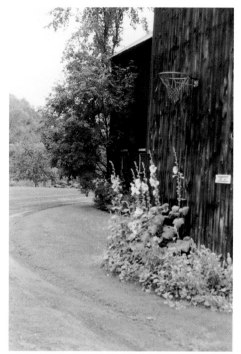

A photograph of barn and hollyhocks. In planning my approach, I decided to open the space up to include the mist-covered trees in the distance. I needed the curving driveway to pull the viewers into the distant space, and I wanted to keep the rendering of the flowers loose enough that they wouldn't dominate the picture.

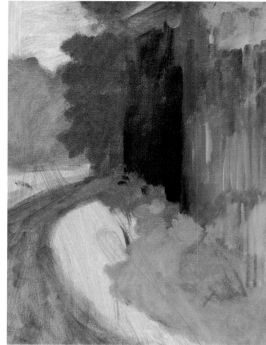

I worked from the distant trees to the foreground shapes using thin washes of color over a burnt sienna ground on a Fredrix canvas panel. I kept the oil paints thin and fluid while creating the picture because I was working on an overcast, damp day when there were soft edges and deep shadows between the forms.

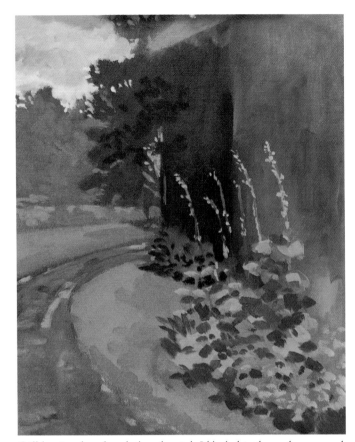

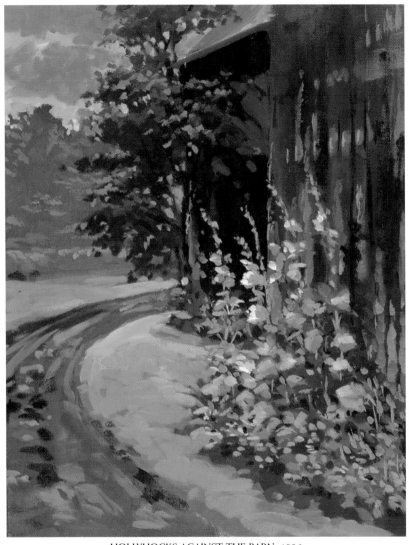

Still keeping the colors dark and muted, I blocked in the road, grass, and sky. I also punched in some light greens to define the trees at the edge of the barn and give the hollyhocks a more definite shape. You'll see that the overall gray tone of the picture made it easy to bring out the brighter highlights on the wet road and hollyhock blossoms.

HOLLYHOCKS AGAINST THE BARN, 1996
Oil, 14 × 11" (35.6 × 27.9 cm). Collection of the artist.

INCLUDING MASSES OF BLOSSOMS

Monet's gardens in Giverny, France, have probably become the most photographed and painted gardens in the world. Peter Ellenshaw has traveled to these spectacular gardens northwest of Paris several times to record the water gardens and poppy fields. His expansive oil and acrylic views, filled with masses of vines, waterlilies, blossoms, trellises, and trees, capture all the lushness and beauty of Monet's creation.

Ellenshaw does not depend on sharp divisions between shadow and sunlit areas to compose his paintings. Instead he uses large foreground shapes and an identifiable middle-ground object (in the painting below, Monet's house) to divide the space within the picture. Everything exists in a clear, midday sunlight, and the artist's use of sparkling highlights gives a heightened sense of realism to the entire picture.

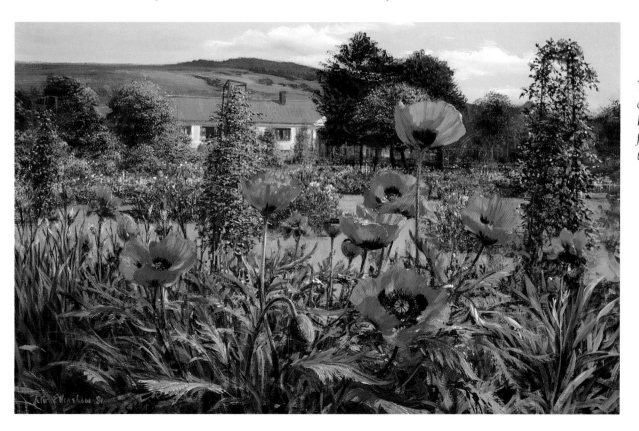

COTTAGE GARDEN,
by Peter Ellenshaw, 1981
Oil, 30 × 48" (76.2 × 121.9 cm).
Courtesy Mill Pond Press, Venice, Florida.

To create this multiply focused painting of the poppies in Monet's garden, Peter Ellenshaw overlapped the shapes of the flowers, house, trees, and distant hills so they became layers of receding forms.

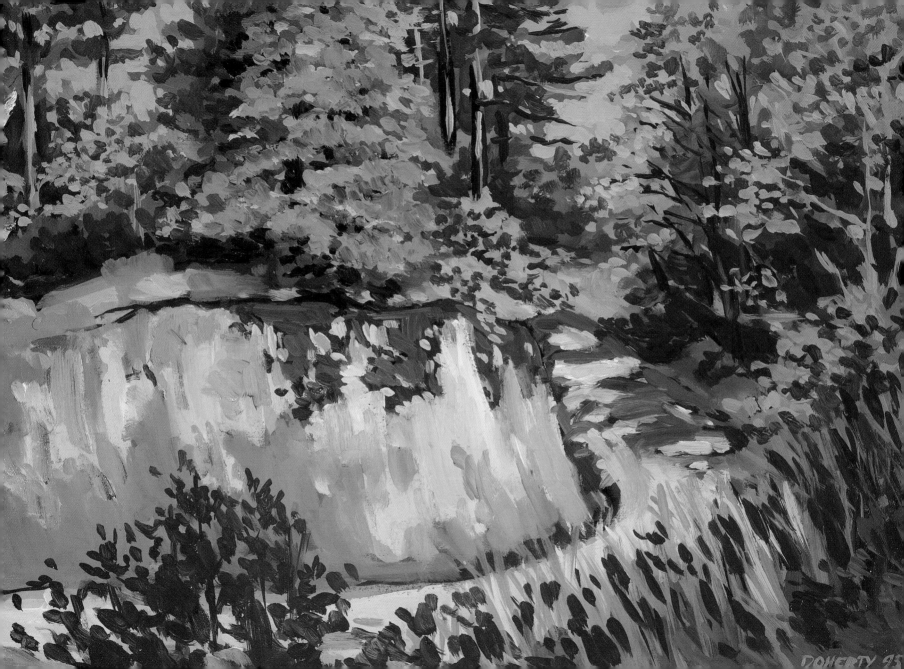

FENCES, ROADS, PATHS, AND BRIDGES

(Above) MOHONK NO. 2, 1991
Gouache on tan Arches paper, 18 × 12" (45.7 × 30.5 cm).
Collection of the artist.

(Opposite) POSSUMNECK, MISSISSIPPI, DETAIL, 1995
Alkyd, 11 × 14" (27.9 × 30.5 cm). Courtesy Bryant Galleries,
Jackson, Mississippi.

*Tall embankments gave a sculptural look to the roads that heaved
their way through rural Mississippi, and it took several attempts
to arrive at the right mix of pigments to match their iron-red color.
I was most satisfied with a combination of cadmium orange,
cadmium red, and titanium white.*

Fences, roads, paths, and bridges can be used to organize the space within a landscape or they can be the main subjects of a picture. As an organizational device, they separate one level of space from another, project the space deeper into the background, or create a rigid foil for the organic shapes within the painting. A pavilion placed within a garden will break up the pattern of greens, a row of houses will deepen the illusion of space, and a brick wall can balance the wildly curving lines of a vine. In the painting on this page, *Mohonk No.* 2, the bridge and pathway leading to the benches divided the scene into equal halves, giving me a opportunity to play with the mirror image of the structure sitting in the middle of an island.

Managing Space with Fences

Having a road or a fence appear within a landscape can be one of the simplest ways of directing the viewer's attention through the pictorial space. The eye quite naturally follows their path from the closest spot to the most distant. But as useful as they might be, if a road or fence drags the viewers into the dead center of the picture and abandons them, then the composition has failed. The artist has to use the device to take the viewer from the desired point of entry into the picture and through the rest of the composition. The line established by the road or fence should weave its way into the space, being extended by a flowing stream, a valley between two mountains, or the clouds floating above. The sketches shown here illustrate a few of the ways a fence can be used in a landscape composition.

A fence going nowhere creates a flat, stagelike space and fails to move the viewer's attention around and through the picture.

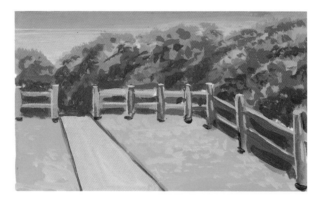

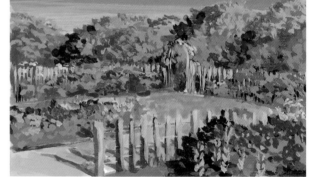

The fence here performs a slightly different function than those in the other sketches. Instead of moving the viewer from one place to another, this garden fence helps to organize the space that would otherwise appear too confusing. It's something like a recurring musical motif that is played between solo performances.

Setting the fence at a more severe angle to the plane of the picture causes it to recede quickly into the distant space. The viewer can't help but feel he or she is entering the landscape right by the post in the foreground and then moving quickly down to the grove of trees in the distance and then back behind the dark trees on the right.

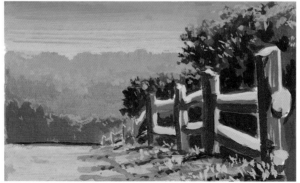

SONDRA'S GARDEN NO. 2, 1996
Oil, 11 × 14" (27.9 × 35.6 cm)

SONDRA'S GARDEN NO. 1, 1995
Alkyd, 11 × 14" (27.9 × 35.6 cm).

A lush garden of greens needs a road, fence, sculpture, or path to divide the space within the picture. Here I've depended on the entrance fence to bring focus and division to the composition.

The curving road, arching trees, and angular shapes move the viewer's eyes around and through the picture.

Guiding Viewers Down Roads

A photograph of the view I found the first time I painted the sugar maple trees in Vermont.

The two road paintings in this section were, like the paintings of Turkey Mountain in Chapter 11, part of a series in which I painted the same scene at different times of the year to show how I might adjust the composition, palette of colors, and brush marks to accurately record what I observed. The location is in southern Vermont where sugar maples line a gravel road. All three paintings were done on panels using alkyd paints, but I would have made similar choices about colors, composition, and brush marks if I had been working with oils, acrylics, or watercolors. My purpose was to show the most interesting aspect of the seasonal landscape—the colors of the leaves, the extent of the view, and the feeling I had while experiencing a damp summer, an arid autumn, and a bitter winter. Any painting medium would have allowed me to express those conditions.

It rained so much during the first summer I traveled to Vermont with my painting supplies that the leaves were an unusually rich yellow-green and the stone walls were a glistening gray-blue. Although I would normally have mixed all my greens from combinations of blues and yellows, I decided to add several tube greens to my palette so I could quickly establish the range of yellow- and blue-greens that I needed. Those included Gamblin's permanent green

light, Holbein's Compose Green No. 4, and Winsor & Newton's Winsor Emerald.

There were touches of autumn reds, oranges, and yellows on the trees along that same Vermont road when I returned the following year on Labor Day weekend. That's probably because the weather had been dry and prematurely cold that year. To convey the differences I found from the previous year, I didn't use any of the tube greens but, instead, mixed yellow ochre, raw umber, and cadmium yellow deep with various blues to get a range of warm, soft greens. The tree trunks and cast shadows needed to be light gray purples and blues to convey the sense of crisp dryness.

I think the composition of this painting is more successful than the summer painting or the winter version (page 89) in that the patterns of trees and roads cause a swirling motion that takes the viewer's attention into the deep space of the picture. The winter painting, for example, lacks the sense of dynamic motion I was able to achieve in the Labor Day painting. It's hard to be completely analytical when you're painting on location because there are so many things that must be accomplished in a limited amount of time, and so many distractions to keep you from remaining focused on the evolving picture.

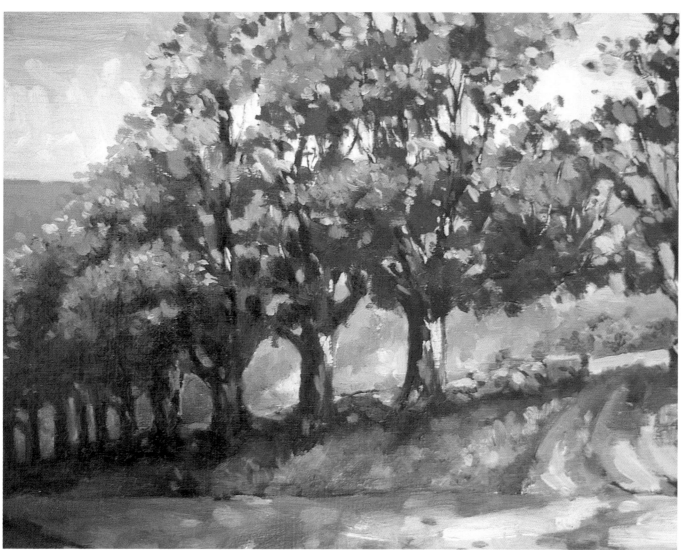

**BALOU HILL ROAD,
SUMMER, 1993**
Alkyd, 11 × 14"
(27.9 × 35.6 cm).

There was a damp, misty quality to the shadows in the lower left-hand corner of the scene and a warm tone to the sunlight hitting the branches of the trees. I have found that one of the best mixtures for these kinds of bright highlights is titanium white with a touch of burnt sienna added, and that's the combination I used for this painting. I did some studio work on this picture after returning from Vermont, using oil paint mixed with Galkyd medium to add finer details in the trees with a round sable brush. I also used a small amount of cobalt blue oil paint mixed with Galkyd medium to make a glaze that would soften the lower left-hand corner of the panel as well as the rock wall under the trees.

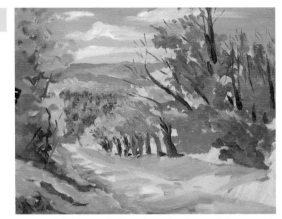

I painted the distant hills and the sky first and then moved forward to block in the trees on the left and right sides of the road. I tried to emphasize the circular movement of the forms to make the composition more dynamic.

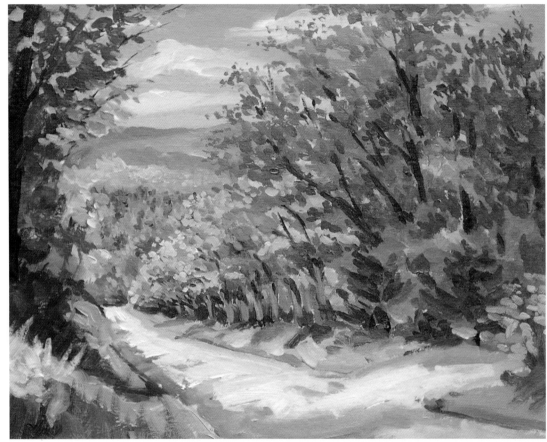

BALOU HILL ROAD, AUTUMN, 1994
Alkyd, 11 × 14" (27.9 × 35.6 cm).

Here again I offer different approaches to using a manmade object (in this case a road, rather than a fence) compositionally in a painting.

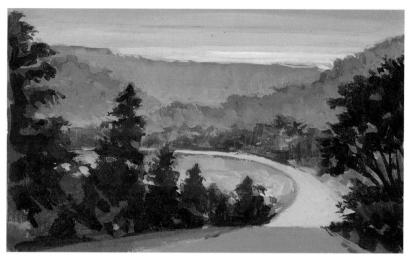

The road cuts right through the middle of the space and abandons the viewer right at the horizon line.

Here the road begins right at the bottom edge of the picture, curves into the middle space, and carries on through the space between the V-shaped mountains. An effort was made to bend and twist the lines implied by the road to bring attention to every part of the rectangular picture. In fact, one can almost imagine that the road winds its way up into the distant hills.

(Right) This painting shows that diagonal and curving roads can be used just as effectively in an abstract landscape as they can in a realistic one. The purple and orange roads in this sketch perform the same task as the road in the representational painting: carrying the viewer's attention around and through the pictorial space, bringing attention to every part of the picture.

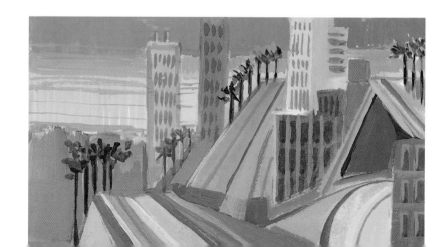

JACK'S TURN, 1994
Alkyd, 11 × 14"
(27.9 × 35.6 cm).
Collection Joan Sullivan.

The intersection of two or more roads can give you the opportunity to develop several planes of space and intersecting vectors. In this painting one road leads up the hill to the left while the other brings the viewer from the foreground down to a lower level of space. The shadow patterns help reinforce this sense of motion and yet slow the pace of the viewer's eye as it travels through the space.

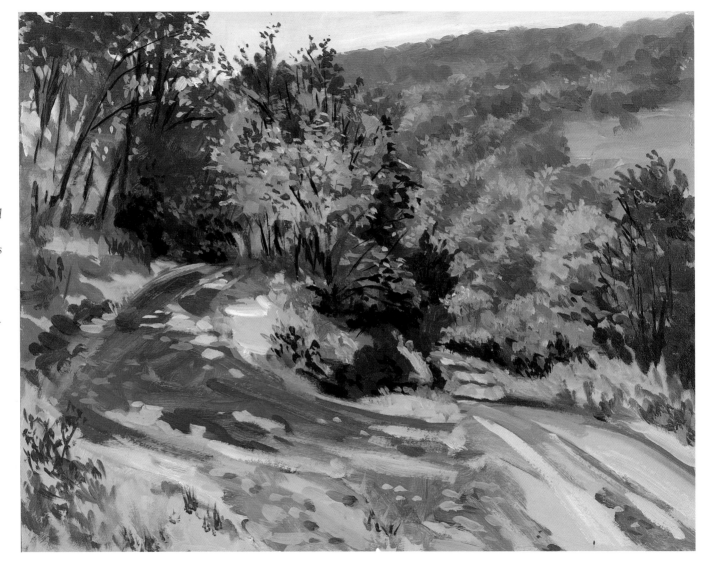

The progressive stages in this painting of a path around a lake show how the curved walkway brings the viewer's attention from the lower right-hand corner across to the left-hand side and then along the far edge of the lake.

Every branch, ripple, and shadow bends in response to the circular motion established by the path.

The Completed Painting:
ROCKEFELLER PATH, 1993
Alkyd, 11 × 14"
(27.9 × 35.6 cm).

The path in this scene offers a simple demonstration of how curving roads can lead the viewer's eye into and through a landscape space.

Focusing on Bridges

THE BRIDGE IN DOONE VALLEY, ENGLAND, 1995
Alkyd, 11 × 14" (27.9 × 35.6 cm).

As usual, it was cold and rainy the morning I tried to paint this bridge, so I was able only to block in the major forms. I completed the picture from photographs and memory after I returned home.

While most bridges serve to move the viewer's attention from one part of a picture to another, they can also become the center of interest all by themselves. In this charming scene in the Exmoor national forest in England, one lane of the road goes across the bridge while the other crosses the stream. The movement within the picture is focused on the water, while the bridge is a stationary architectural feature buried in the foliage of the trees.

ADDING BRIDGES AS DECORATIONS

The gardens at Stourhead in England were designed to be painted, and they have been by thousands of artists since they were built in the eighteenth century. When I set my easel up to paint one of the many intriguing scenes, I almost felt that the landscape architect had carved an X in the ground to tell me where I should stand to get the best compositional arrangement of the bridge, pond, trees, and distant building.

None of the structures in this scene are there to perform some essential function. They are all decorative elements in a designed space. Certainly one could walk across the grass-covered bridge, but it would be just as easy to walk around the pond on the continuous path.

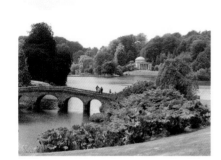

A photograph of Stourhead, one of the most beautifully planned and appointed gardens in England.

STOURHEAD, 1995
Alkyd, 11 × 14" (27.9 × 35.6 cm).

In terms of the composition of this painting, it's clear that the bridge is just a decorative element—a charming one, but a decorative element nonetheless.

USING BRIDGES FOR TRANSITION

A bridge—whether a small footbridge across a stream or the Golden Gate Bridge spanning the San Francisco Bay—often plays the important role of linking two sections of a landscape.

As I've wandered around large parks or estates looking for an interesting view worth painting, I have often decided on the area where a bridge cuts through the greenery. The painting shown here in stages of development is of a small but beautifully designed bridge crossing a stream on the Vanderbilt estate in Hyde Park, New York. I drove back and forth along the roads leading to the grand house, the hunting lodge, and the park overlooking the Hudson River and decided that the bridge near the entrance to the property was the focal point of the most appealing part of the estate. While the main house dominated everything around it, the bridge was nestled into the hillside. While the Hudson view was wide open and complicated, the bridge sat within an intimate grove of trees and bushes. It was a scene that was asking to be painted.

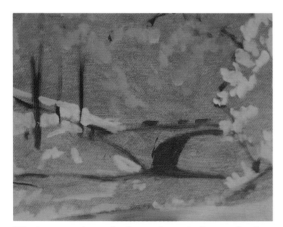 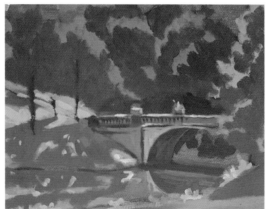 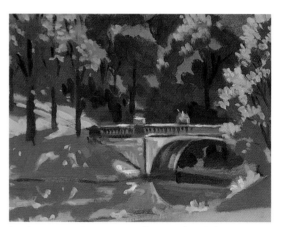

Here's a case where a bridge works perfectly as a focal point and a compositional device linking directional forces within a landscape. Working on a surface toned with burnt sienna, I established the darkest darks then the lightest lights before painting the mid-tones.

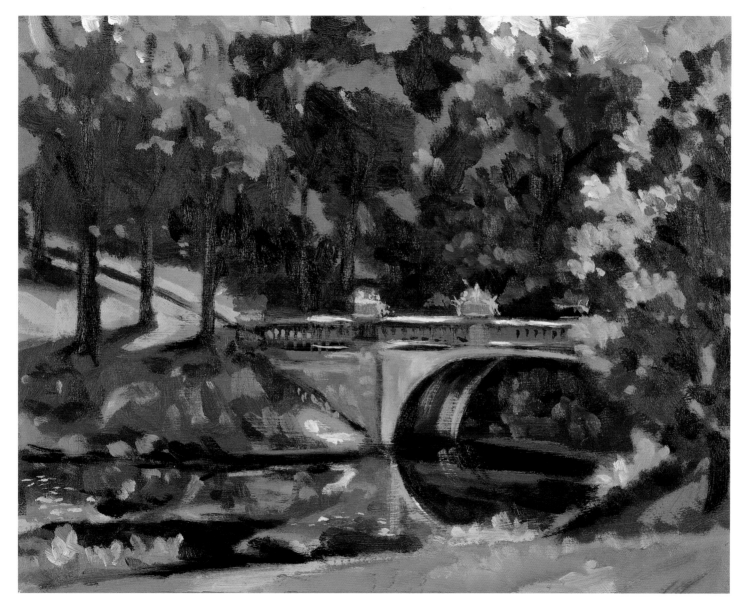

The Completed
Painting:
**VANDERBILT
BRIDGE**, 1993
Alkyd, 11 × 14"
(27.9 × 35.6 cm).

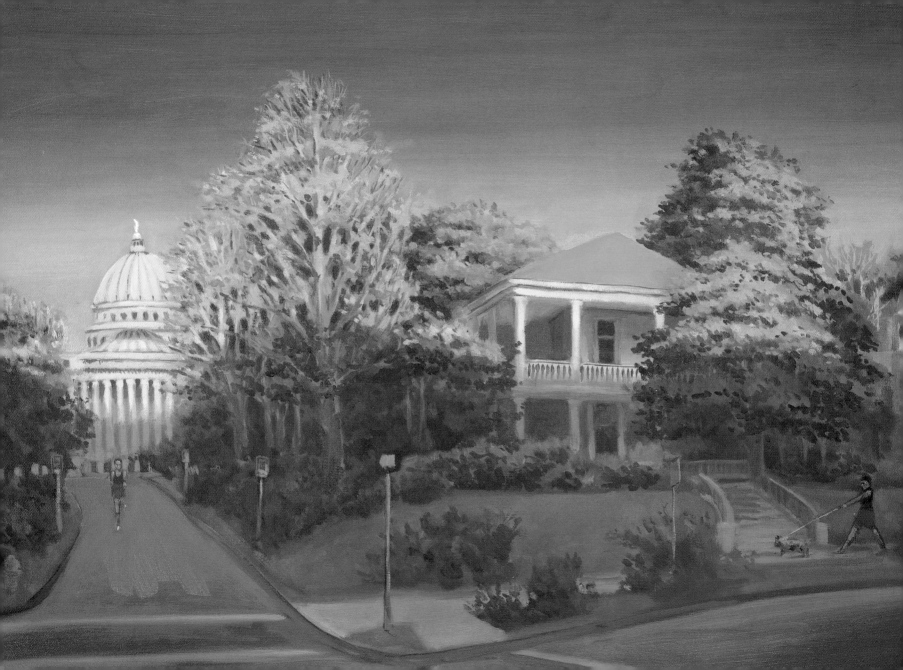

USING URBAN PLANES

(Above) SACRED HEART ACADEMY, NEW ORLEANS, 1995
Alkyd, 18 × 24" (45.7 × 61 cm). Courtesy Bryant Galleries,
New Orleans, Louisiana.

For this painting I avoided a symmetrical composition by setting up my easel just to the right, where I would pick up more of the shadows and get a better integration of trees and building.

(Opposite) MORNING IN MISSISSIPPI (detail), 1995
Oil, 20 × 30" (50.8 × 76.2 cm). Courtesy Bryant Galleries,
Jackson, Mississippi.

I captured the feeling of early morning in an urban location by using a low angle of light to reveal the tops of buildings and trees.

Artists create urban and suburban scenes as a way of saying something about the landscapes shaped by people for their work and pleasure. They show us places planned, built, and decorated by people, and the message that comes through in the paintings relates to the artists' attitudes about the inhabitants of those spaces. The painters may focus on tall buildings, uniform houses, backyard gardens, bustling streets, advertising signage, or nostalgic scenes of another era. But whatever the subject, it will convey a distinctly different feeling than a landscapes of lakes, mountains, deserts, and skies.

Scale and Placement

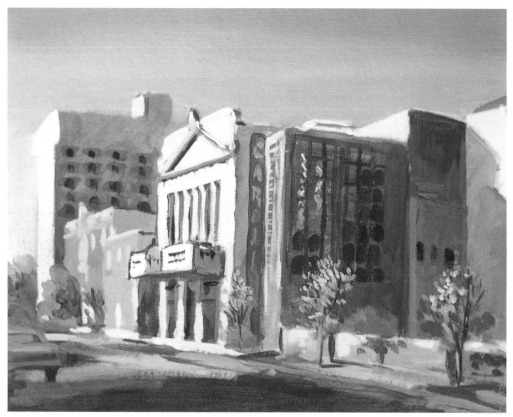

THE CAROLINA THEATRE, GREENSBORO, NORTH CAROLINA, 1995
Alkyd, 11 x 14" (27.9 × 35.6 cm).

Linear perspective can be a complicated study of objects in space, but there are a few simple principles that one can use in helping to determine the scale and placement of buildings, roads, fences, windows, and other elements of an urban landscape. I've made a line drawing of the buildings included in a painting of downtown Greensboro, North Carolina, which shows how the parallel lines of buildings lined up along a street will all appear to converge at one point on the horizon (the line established by the level of your vision). I could have also drawn the lines that would converge at a point on the horizon to the right side of the picture. While these alignments may not be as true to reality as those in George Nick's paintings, three of which are reproduced on the following pages, they are convincing to the viewers of the painting.

A diagram showing how the parallel lines established by roofs, windows, fences, and marquees converge to the same point on the horizon line.

DRAWING IN BUILDING PLANES

As already pointed out, perspective is often an important consideration when you are painting buildings, and it's advisable to spend a little more time drawing out a scene that includes buildings if you want them to appear accurately placed within the landscape. The drawing can be done in graphite or charcoal, or you can simply sketch in the important lines with a thin mixture of paint. The point is to make sure the scale of the drawing will allow you to include all the important elements and that the perspective lines project accurately into the pictorial space.

In painting this house in New Orleans, I first drew the lines of the building as if there were no trees blocking my view. I had to make sure the structure would seem accurately placed after all the other elements were added. After finishing the painting, I decided to make a small etching of the same scene because I thought the play of shadows and forms would translate well into a black & white image.

McCULLAN HOUSE, 1994
Etching, 8 × 10" (20.3 × 25.4 cm).

I liked my painting of the McCullan house so much I decided to use it as the basis of a line and aquatint etching.

McCULLAN HOUSE, 1994
Alkyd, 11 × 14" (27.9 × 35.6 cm).
Collection Patrick Joseph Waide.

47TH AND BROADWAY, by George Nick, 1994
Oil, 40 × 40" (101.6 × 101.6 cm).
Courtesy Fischbach Galleries, New York, New York.

PURE URBAN PLANES: GEORGE NICK

George Nick has been painting buildings in Boston, New York, and other urban centers for decades, and his process is nothing short of amazing. He takes his large canvases out on location and spends days and weeks making a carefully detailed pencil drawing and then painting the picture with thick strokes of oil paint. He is so particular about the accuracy of his drawing that he will often look through a gridded viewer to make sure the lines established by the sides of buildings, lampposts, doorways, sidewalks, and roads are accurate in terms of their scale and perspective.

While it may appear at times that Nick is looking through the fish-eye lens of a camera when he draws the curving lines of a building, he can prove that those lines do bend toward the horizon exactly as he has drawn them.

CHASING APOLLO, by George Nick, 1996
Oil, 40 × 60" (101.6 × 152.4 cm).
Courtesy Fischbach Galleries, New York, New York.

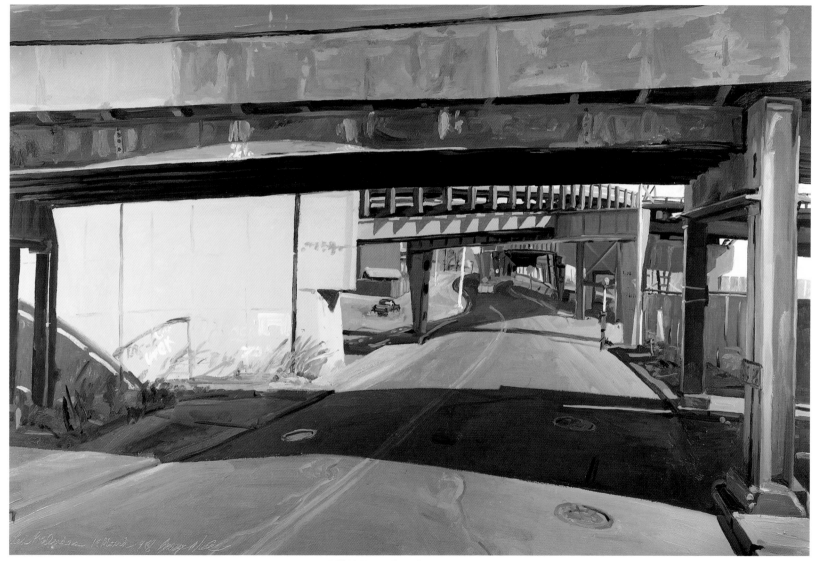

LES PRELUDES, by George Nick, 1988
Oil, 40 × 60" (101.6 × 152.4 cm). Courtesy Fischbach Gallery, New York, New York.

Demonstration: PUSHING BUILDINGS INTO THE BACKGROUND

I set up my half French easel along one of the streets of the Garden District in New Orleans to be able to paint the morning sunlight on this house.

When I've painted the Victorian houses of the Garden District in New Orleans or the thatched-roof houses of England, I've made a point of nestling the buildings into the trees and bushes that surround them because I don't want my finished paintings to look like real estate advertisements. The buildings have to become part of the composition, not isolated pieces of architecture.

While I spent a lot of time painting the details of this corner building, I also filled the picture with bushes and trees that surround the ornate structure. When someone who saw the painting started identifying the types of vegetation, I knew I had been successful in establishing a context for the home.

I sketched in the building and sidewalks and then put a wash of purple over the front side of the house so the shadows would be cool in tone.

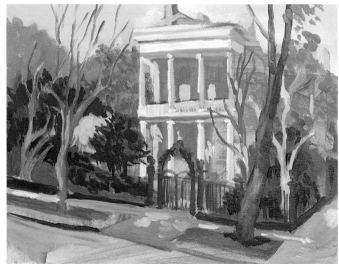

I blocked in the trees, sidewalk, and fence before finishing the details of the house.

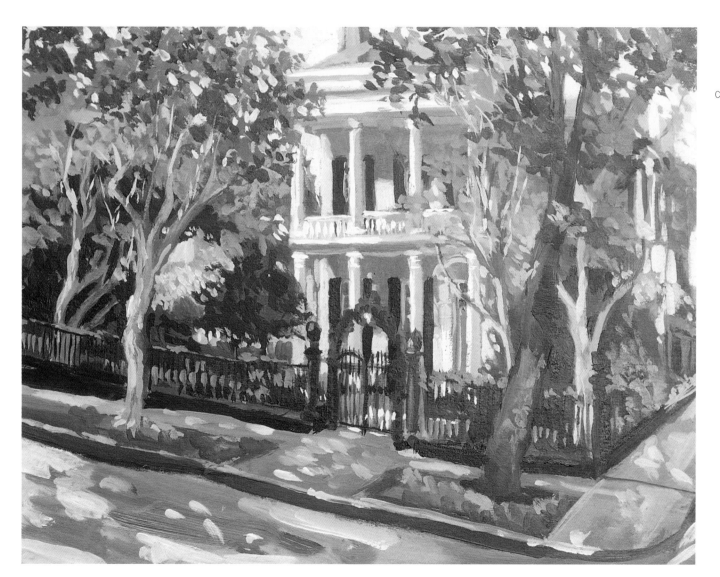

The Completed Painting:
GARDEN DISTRICT
MANSION, 1994
Alkyd, 11 × 14"
(27.9 × 35.6 cm).
Collection William Mangum.

Featuring Sentimental Favorites

I am often asked by companies that publish reproductions of paintings to recommend artists who paint sentimental subjects because those are the most popular with buyers of inexpensive prints, posters, and reproductions. Images of quaint cottages, romantic cafés, nostalgic scenes, historic events, or favorite movie scenes create the kinds of emotional response many people want from a work of art. But my problem in trying to make these recommendations is that most artists would rather break their brushes in half than paint something sweet, romantic, and sentimental.

The challenge for artists who want to sell to the general market is to find a subject which genuinely interests them which will also appeal to the general public. Paintings of flowers, historic landmarks, old cities, costumed figures, and elegant interiors often serve this dual purpose. One artist I know has been enormously successful with paintings of sun-filled beach scenes, another with images of English cottages, and a third with oils of French cafés.

PAINTING HISTORIC BUILDINGS

If a building is a historic landmark well known to people in a region, it is likely to be both a terrific subject for a painting, and a terrible one. On the one hand it is a subject about which lots of people have strong positive feelings, and that means your painting is bound to strike a responsive chord in the hearts of those who see it; but it will also be a picture viewed by people who want to count the number of windows and doors because they expect the painting to be a completely accurate depiction of the structure. I had one woman refuse to buy my painting of her historic home because I didn't have the correct number of flower baskets hanging from the balcony!

In painting one sentimental favorite of New Orleans residents—the Sacred Heart Academy shown on the opening page of this chapter—I made sure my painting offered a different interpretation from the line drawing on the school's dinnerware, napkins, and stationery, by placing the sprawling building in a setting of live oak trees along St. Charles Avenue.

The painting on the opposite page is of another popular favorite—a New England landmark, the church in Bennington, Vermont, behind which the poet Robert Frost and his family are buried.

STANTON HALL,
NATCHEZ, MISSISSIPPI, 1995
Alkyd, 11 × 14" (27.9 × 35.6 cm).
Courtesy Bryant Galleries,
Jackson, Mississippi.

In painting this popular architectural landmark, the Stanton Hall mansion in Natchez, Mississippi, I set the famous portico into a distinctly spring-time setting by emphasizing the budding trees and flowering azaleas.

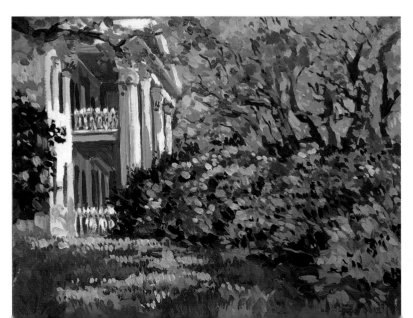

To paint the church shown here, I positioned myself off to the side where I could use the pattern of sunlight and shadow, as well as the surrounding trees, to make the painting into something more than a postcard view.

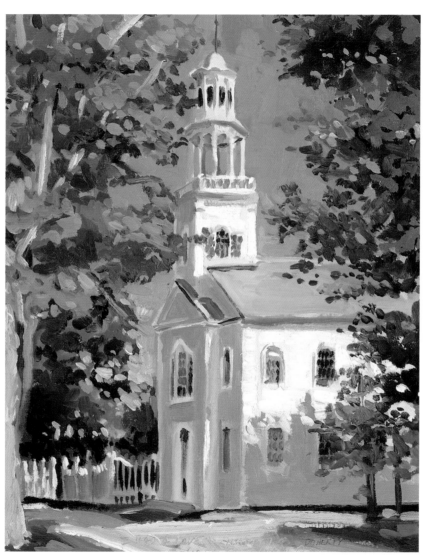

VERMONT CHURCH, 1994
Alkyd, 14 × 11" (35.6 × 27.9 cm).

Working on a panel toned with gray-blue, I sketched in the church with thin paint and then painted the blue sky to silhouette the structure. Next I painted the sunlit side of the building with titanium white. Because buildings generally need more detailing than trees, I concentrated on the tower and windows of the church before filling in the greenery. I avoided making the windows too sharply defined or too regular in their appearance. When I had finished the painting, I scratched Robert Frost's epitaph into the paint along the bottom of the picture: "I had a lover's quarrel with life."

Index